10/27/15
$29.99
I

145

Withdrawn

Everywhere radiance glows like a garden in stillness blossoming.

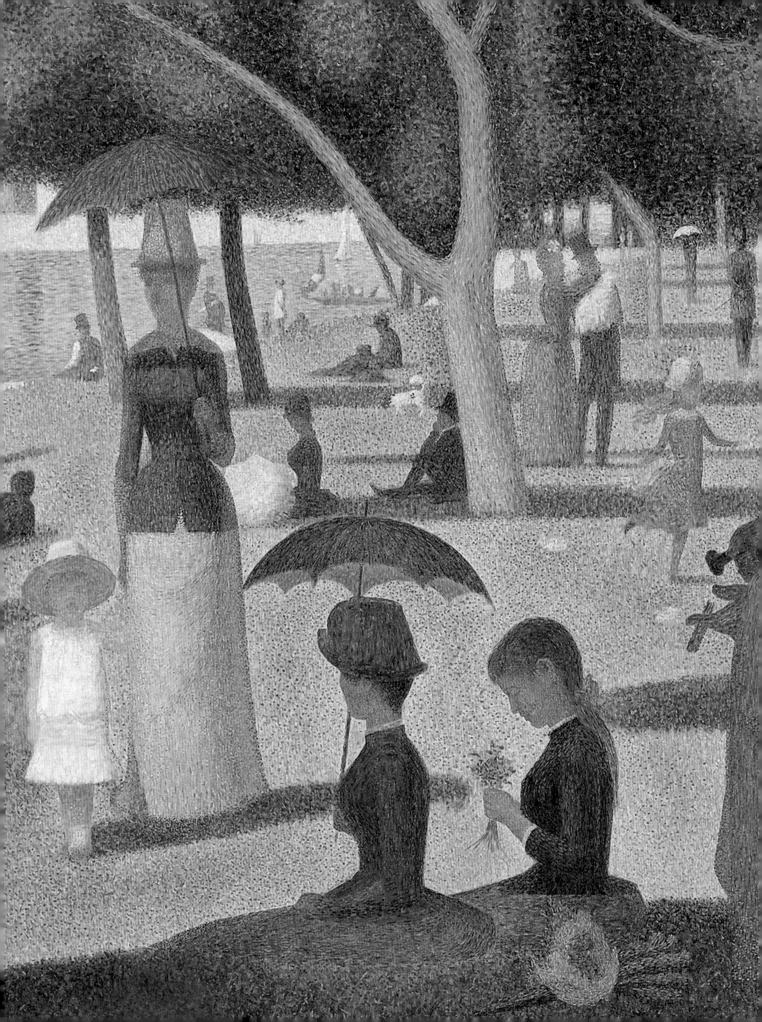

SUNLIGHT ON THE RIVER

POEMS *about* PAINTINGS · PAINTINGS *about* POEMS

EDITED BY SCOTT GUTTERMAN

PRESTEL
MUNICH · LONDON · NEW YORK

CONTENTS

For Sid and Syl

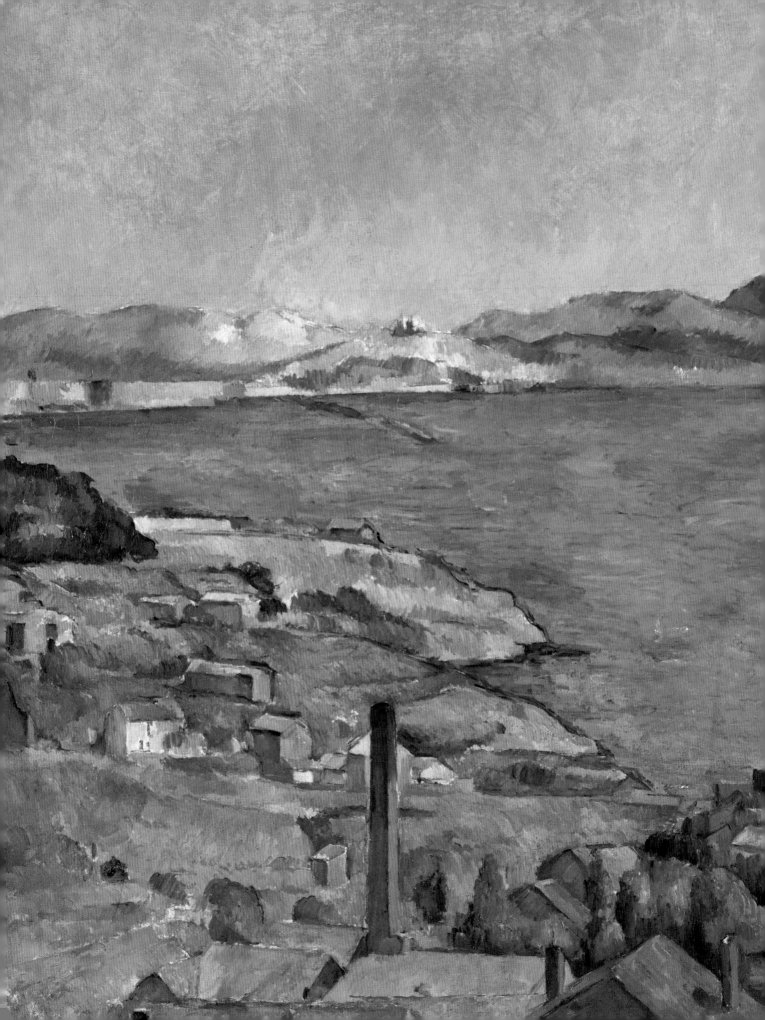

Introduction

by Scott Gutterman

All art is about transformation. The observation by the artist Jasper Johns of his working method ("Take an object. Do something to it. Do something else to it") is at the heart of *ekphrasis*: broadly speaking, one art form based on another, but in this context referring to poems about paintings, as well as paintings based on poems.

A transformed object — a poem, a painting — is further transformed by being imagined and realized in a different medium. "Things as they are / Are changed upon the blue guitar," observed Wallace Stevens in his distillation of the Picasso painting he references.

I was first introduced to *ekphrasis* (from the Latin "ek," out of, and "phrasis," speech) through the work of Delmore Schwartz. I found a poem of his based on the famous Georges Seurat painting, *A Sunday on La Grande Jatte*. "What are they looking at?" it begins. "Is it the river? The sunlight on the river?" Following the path of these plainspoken questions, I had a way in to the picture, to its deeper currents. I felt that I could enter the imaginative space of the painting. The poem and the painting fused into something greater: a meditation linking thought and feeling, the literary and the visual.

Seeking out other examples of this art and literature nexus, I learned that William Carlos Williams had written a whole series of poems called "Pictures from Breughel," in which he brings his singing, demotic language to bear on a batch of brilliantly detailed rustic scenes. With "The Wedding Dance in the Open Air," he even approximates the whirring dance of the participants through language: the poem becomes the painting, the music, and the barreling movement of the wedding guests all at once.

Poets approach the paintings that inspire them in a variety of ways. W.H. Auden, in one of the most famous ekphrastic poems, "Musée des Beaux Arts," considers Breughel's "The Fall of Icarus" and locates within it a profound meditation on human existence. He observes that, in the painting, the central event —"a boy falling out of the sky"— is depicted simply by a pair of "white legs disappearing into the green / Water." But the ploughman at the core of the picture never looks up from his work, and the "expensive delicate ship" just beyond the drowning figure "had somewhere to go and sailed calmly on." Breughel's canvas leads Auden to acknowledge that dear and dreadful things are always happening at the same time, that the innocent and the damned are bound together on earth, and in the end neither can save (and very well may not even notice) the other.

A painting may be an occasion for dramatic writing, as in the imagined inner monologue of Vincent van Gogh, as rendered by Robert Fagles ("I fling my arms to the sun while there is time / I rise with these great flowers dying into life.") It may be a foil for humor, as in the deadpan musings of Kenneth Koch and Jane Freilicher on the components of a car ("Choke: I am a bloke. My name is choke. / Wheel: I am a wheel, central feel of the automobile.") Poets sometimes sing an ode directly to the subject of a painting. This may be evoked with grand language, as J.M.W. Turner's painting of a retired British ship of war is rendered by Herman Melville ("O Tital Temeraire, / Your stern-lights fade away; / Your bulwarks to the years must yield, / And heart-of-oak decay"). Or it maybe be served by simple speech, as the girl with the pearl earring is addressed by Adam Zagajewski ("Oh, Vermeer's little girl, oh pearl, / blue turban; you are all light / and I am made of shadow.")

Most of the pairings in this book are of poems based on paintings. But there are rarer examples of artworks based on poems: Robert Rauschenberg's mysterious evocation of Dante, Francis Bacon's blood and guts take on T.S. Eliot, Bill Viola's meditation on a single line from Rumi. Henri Matisse was especially enamored of poetry and illustrated the work of several poets, as did Joan Mitchell.

Special mention is due to the great New York poet, Frank O'Hara, who befriended many artists and whose writing often formed a bridge to their work. His brilliantly witty discourse, "Why I Am Not a Painter," lays out the differences between poetry and painting though his encounter with the abstract artist Mike Goldberg. When O'Hara drops by Goldberg's studio, he notes of a work in progress, "You have SARDINES in it." His friend replies, "Yes, it needed something there." But when he comes back several days later, the image is gone: "'It was too much,' Mike says." Painting requires Goldberg to balance the space of the canvas, to scrape away and fill in until the arrangement is correct. But when O'Hara works on a poem based on the color orange, "Pretty soon it is a / whole page of words, not lines. / Then another page. There should be / so much more, not of orange, of / words, of how terrible orange is / and life." The poem grows and gathers force, becoming a vehicle for O'Hara's quicksilver perceptions and wounded feelings, while the Goldberg painting contains its worked-over mysteries deep within its canvas grid.

The subject of death turns up in a number of works, from John Keats gazing on the Elgin Marbles ("My spirit is too weak — mortality / Weighs heavily on me like unwilling sleep") to Pierre de Ronsard's meditation on roses ("Ah, time is flying, lady — time is flying; / Nay, tis not time that flies but we that go.") But art, whether in the form of

painting or poetry, is the refuge, the place of return, as in Charles Wright's homage to Paul Cézanne: "The music of everything, syllable after syllable / Out of the burning chair, out of the beings of light. / It all comes back."

I first proposed this book to a publishing house I worked for nearly 30 years ago. When they passed on it, I left it aside, but it kept percolating in my mind. There it stayed, until an opportunity to complete it came to me through a writing fellowship in Italy. I am grateful to the Siena Art Institute for giving me the opportunity to move this long dreamt of project toward completion. I also wish to thank Prestel for their great care in realizing this publication; Ronald Lauder and Renée Price for their steadfast support; Judy Hudson for her superb design of the book; Janis Staggs for her invaluable assistance in obtaining the rights to reprint these words and images; Rebecca Pennucci and Olivia Schaaf for their extremely helpful research; and Rebecca Lewis for her author photo. I have been so lucky to benefit from the knowledge of great teachers, and wish to acknowledge Zoanne Dusebury and Wallace Gray among them. My heartfelt thanks to all my friends and family for their love and support. Jamie Kay and Michael Gutterman remain my joy and inspiration.

My criterion for this book was simple: great poems and superb works of art, which combine to form something dazzling — something that endures, as Rilke imagined, "as the arrow endures the string, / To form, in the gathering outleap, something greater than itself."

Archaic Torso of Apollo

Rainer Maria Rilke

We cannot know his legendary head
with eyes like ripening fruit. And yet his torso
is still suffused with brilliance from inside,
like a lamp, in which his gaze, now turned to low,

gleams in all its power. Otherwise
the curved breast could not dazzle you so, nor could
a smile run through the placid hips and thighs
to that dark center where procreation flared.

Otherwise this stone would seem defaced
beneath the translucent cascade of the shoulders
and would not glisten like a wild beast's fur:

would not, from all the borders of itself,
burst like a star: for here there is no place
that does not see you. You must change your life.

(*Translated by Stephen Mitchell*)

Torso of Milet

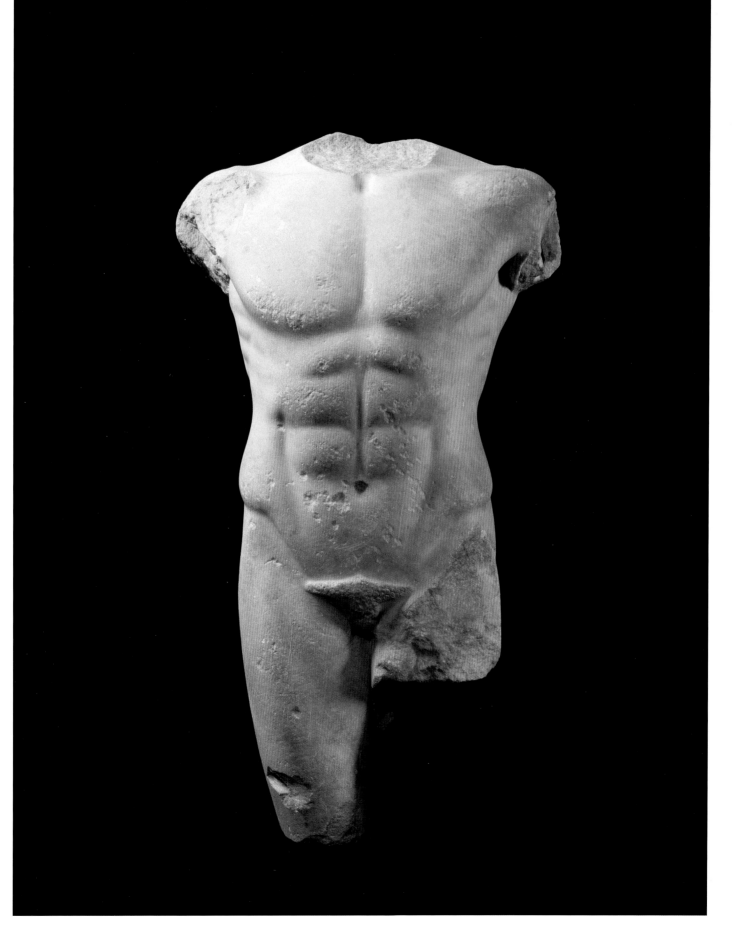

Die Mühle Brennt

Richard Matthews

When the red chair suspended in air
grazes the top of your head
and the white pitcher that rests on the chair

neither falls nor spills, you will move
to the window, or the empty space
in the wall left by the guns on the hill

just outside the city, and be amazed
at the mill ablaze in the distance,
the loud report of dry beams knuckled

under heat, the carousel of shadows spun
around the orange center of the flames,
because you know this cannot happen here

or because you know the mill's been on fire
for so long that the city's been consumed
entirely and the heat from the mill

has blistered the red paint on the chair
and dried the water from the pitcher,
and, if you wait one more instant,

afraid that it is too late, it will be too late,
and the chair and pitcher will drift
through your hair as ash.

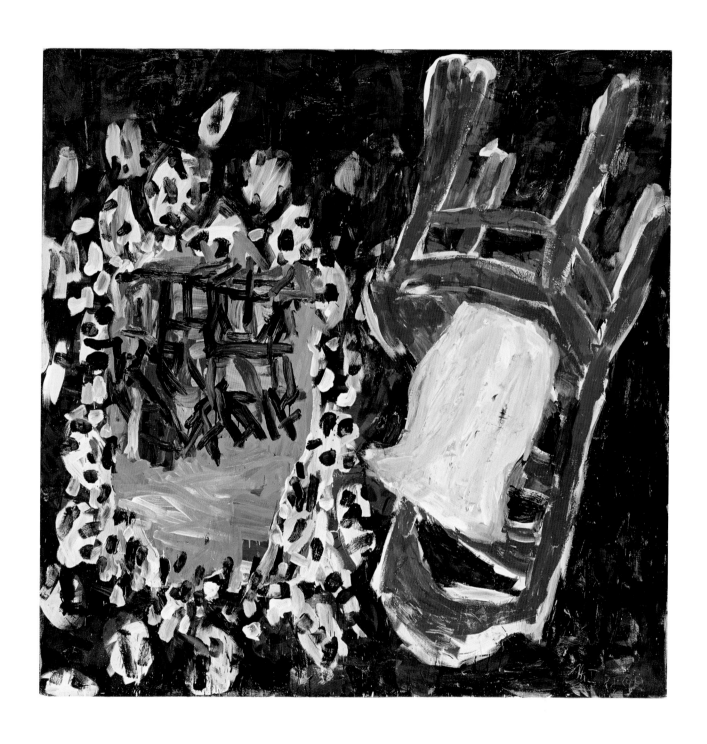

Georg Baselitz

The Mill is Burning — Richard

The Great Figure

William Carlos Williams

Among the rain
and lights
I saw the figure 5
in gold
on a red
fire truck
moving
tense
unheeded
to gong clangs
siren howls
and wheels rumbling
through the dark city.

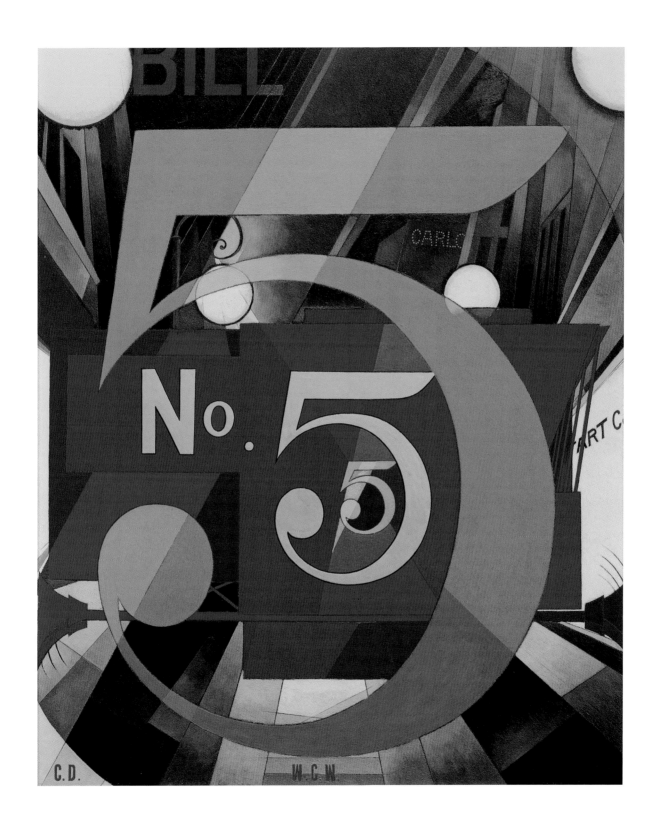

Charles Demuth
I Saw the Figure 5 in Gold

Cézanne's Ports

Allen Ginsberg

In the foreground we see time and life
swept in a race
toward the left hand side of the picture
where shore meets shore.

But that meeting place
isn't represented;
it doesn't occur on the canvas.

For the other side of the bay
is Heaven and Eternity,
with a bleak white haze over its mountains.

And the immense water of L'Estaque is a go-between
for minute rowboats.

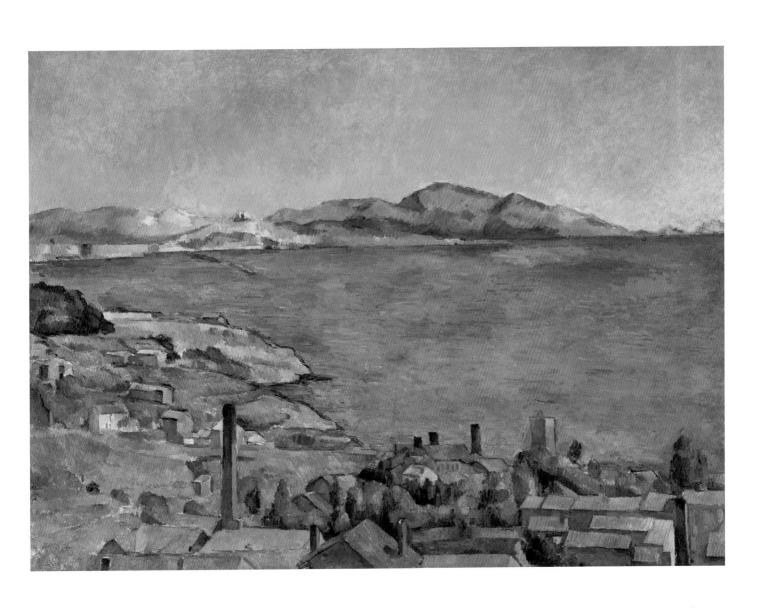

Paul Cézanne
The Gulf of Marseilles Seen from L'Estaque

Mourning Picture

Adrienne Rich

They have carried the mahogany chair and the cane rocker
out under the lilac bush,
and my father and mother darkly sit there, in black clothes.
Our clapboard house stands fast on its hill,
my doll lies in her wicker pram
gazing at western Massachusetts.
This was our world.
I could remake each shaft of grass
feeling its rasp on my fingers,
draw out the map of every lilac leaf
or the net of veins on my father's
grief-tranced hand.

Out of my head, half-bursting,
still filling, the dream condenses —
shadows, crystals, ceilings, meadows, globes of dew.
Under the dull green of the lilacs, out in the light
carving each spoke of the pram, the turned porch-pillars,
under high early-summer clouds,
I am Effie, visible and invisible,
remembering and remembered.

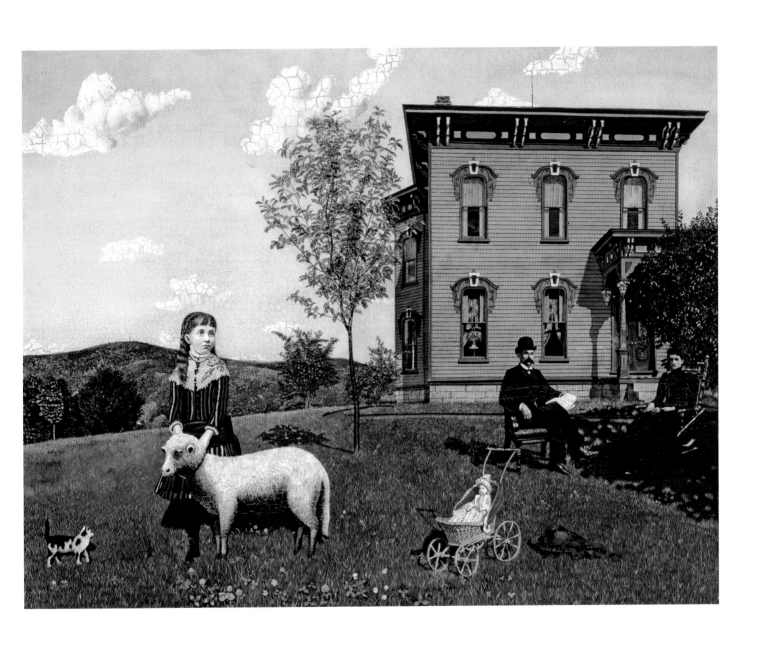

Edwin Romanzo Elmer

Mourning

Excerpt from

Seurat's Sunday Afternoon Along the Seine

Delmore Schwartz

What are they looking at? Is it the river?
The sunlight on the river, the summer, leisure,
Or the luxury and nothingness of consciousness?
A little girl skips, a ring-tailed monkey hops
Like a kangaroo, held by a lady's lead
(Does the husband tax the Congo for the monkey's keep?)
The hopping monkey cannot follow the poodle dashing ahead.

Everyone holds his heart within his hands:

A prayer, a pledge of grace or gratitude
A devout offering to the god of summer, Sunday and plenitude.

The Sunday people are looking at hope itself.

They are looking at hope itself, under the sun, free from the teething
anxiety, the gnawing nervousness
Which wastes so many days and years of consciousness.

· · ·

Everywhere radiance glows like a garden in stillness blossoming.

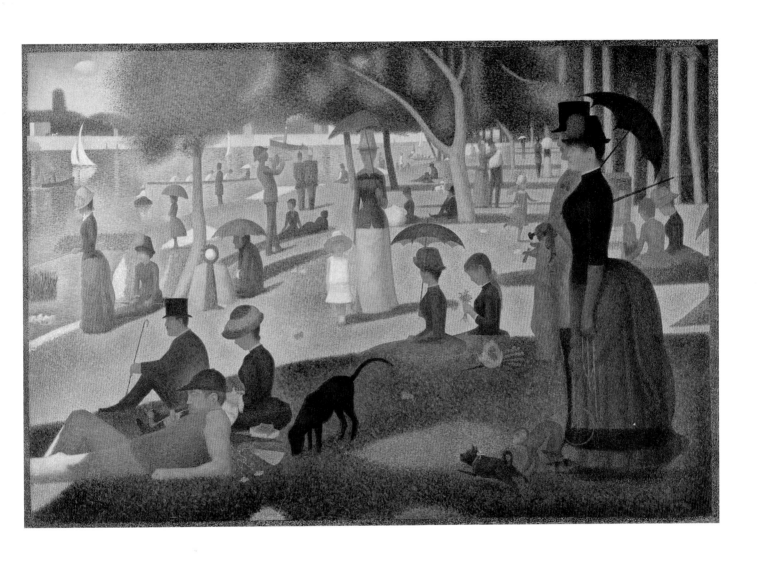

Georges Seurat

A Sunday on La Grande Jatte

Musée des Beaux Arts

W.H. Auden

About suffering they were never wrong,
The old Masters: how well they understood
Its human position: how it takes place
While someone else is eating or opening a window
or just walking dully along;
How, when the aged are reverently, passionately waiting
For the miraculous birth, there always must be
Children who did not specially want it to happen, skating
On a pond at the edge of the wood:
They never forgot
That even the dreadful martyrdom must run its course
Anyhow in a corner, some untidy spot
Where the dogs go on with their doggy life and the torturer's horse
Scratches its innocent behind on a tree.

In Breughel's Icarus, for instance: how everything turns away
Quite leisurely from the disaster; the ploughman may
Have heard the splash, the forsaken cry,
But for him it was not an important failure; the sun shone
As it had to on the white legs disappearing into the green
Water, and the expensive delicate ship that must have seen
Something amazing, a boy falling out of the sky,
Had somewhere to get to and sailed calmly on.

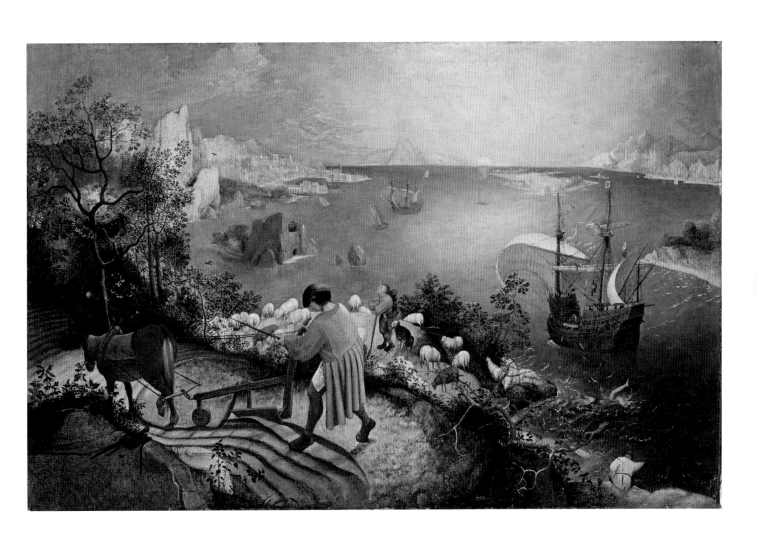

Pieter Brueghel the Elder
Landscape with the Fall of Icarus

The Wedding Dance in the Open Air

William Carlos Williams

Disciplined by the artist
to go round
and round

in holiday gear
a riotously gay rabble of
peasants and their

ample-bottomed doxies
fills
the market square

featured by the women in
their starched
white headgear

they prance or go openly
toward the wood's
edges

round and around in
rough shoes and
farm breeches

mouths agape
Oya!
kicking up their heels

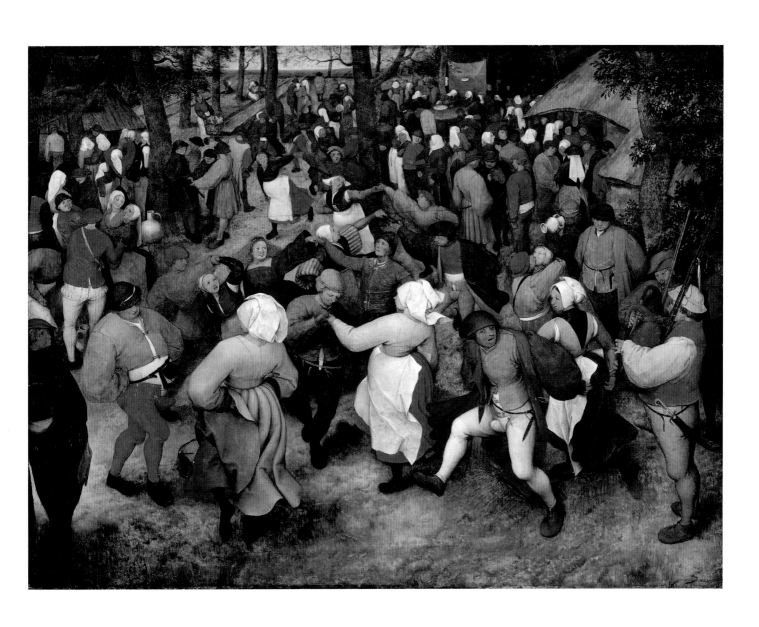

Pieter Brueghel the Elder
The Wedding Dance

The Man with the Blue Guitar

Wallace Stevens

The man bent over his guitar,
A shearsman of sorts. The day was green.

They said, "You have a blue guitar,
You do not play things as they are."

The man replied, "Things as they are
Are changed upon the blue guitar."

And they said then, "But play you must,
A tune beyond us, yet ourselves,

A tune upon the blue guitar
Of things exactly as they are."

• • •

A tune beyond us as we are,
Yet nothing changed by the blue guitar;

Ourselves in the tune as if in space,
Yet nothing changed, except the place

Of things as they are and only the place
As you play them, on the blue guitar,

Placed, so, beyond the compass of change,
Perceived in a final atmosphere;

For a moment final, in the way
The thinking of art seems final when

The thinking of god is smoky dew
The tune is space. The blue guitar

Becomes the place of things as they are,
A composing of senses of the guitar.

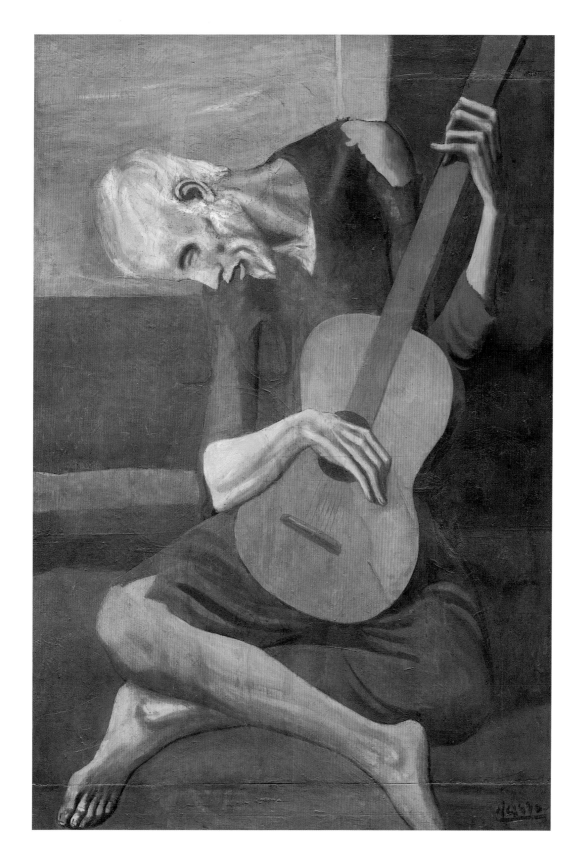

Pablo Picasso

The Old Guitarist

Excerpt from

Homage to Paul Cézanne

Charles Wright

Each year the dead grow less dead, and nudge
Close to the surface of all things.
They start to remember the silence that brought them here.
They start to recount the gain in their soiled hands.

Their glasses let loose, and grain by grain return to the riverbank.
They point to their favorite words
Growing around them, revealed as themselves for the first time:
They stand close to the meanings and take them in.

They stand there, vague and without pain,
Under their fingernails an unreturnable dirt.
They stand there and it comes back,
The music of everything, syllable after syllable

Out of the burning chair, out of the beings of light.
It all comes back.

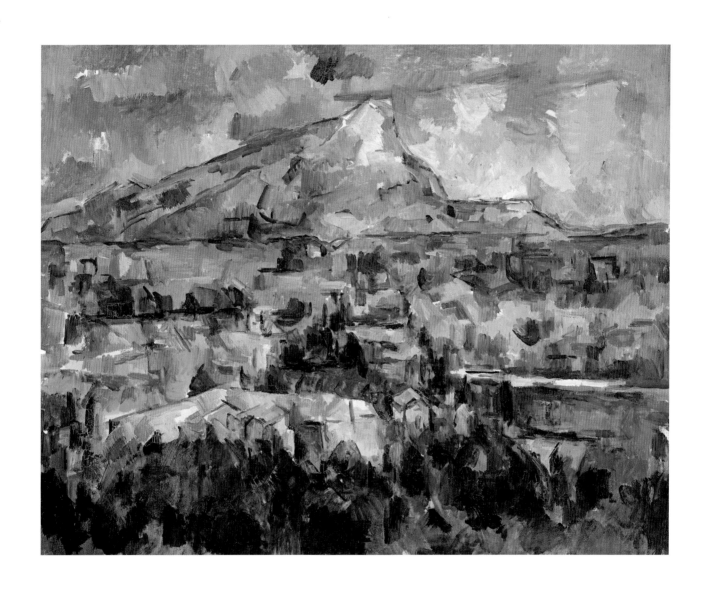

Paul Cézanne
Mont Sainte-Victoire

Guernica

Norman Rosten

In Guernica the dead children
Were laid out in order upon the sidewalk,
In their white starched dresses,
In their pitiful white dresses.
On their foreheads and breasts
Are the little holes where death came in
As thunder, while they were playing
Their important summer games.
Do not weep for them, madre.
They are gone forever, the little ones,
Straight to heaven to the saints,
and God will fill the bullet-holes with candy.

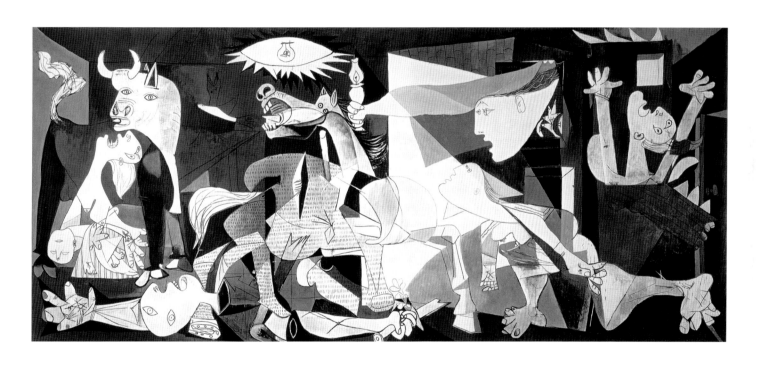

Pablo Picasso

Guernica

Excerpt from

The Jinx

Stéphane Mallarmé

Above the dumbfounded human herd
the brilliant, savage manes of blue-
starved beggars leapt, their feet already in our way.

A black wind deployed as banner over their march
whipped it with cold so far into the flesh
that it hollowed irritable furrows.

Always in hope of arriving at the sea,
they voyaged without bread, or sticks, or urns,
biting the golden lemon of the bitter ideal.

Most grieved their last gasp in the night parades,
drunk on the joy of seeing their own blood flow,
O Death, the only kiss for speechless mouths!

(*Translated by Peter Manson*)

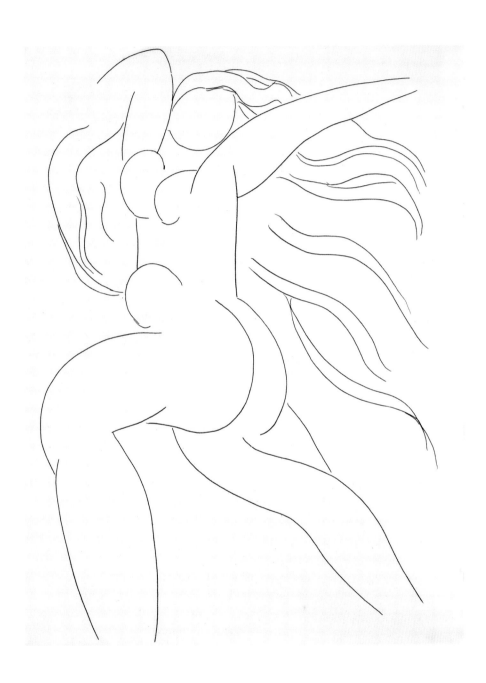

Henri Matisse

"Le Guignon" from "Poésies de Stéphane Mallarmé"

Museum Piece

Richard Wilbur

The good gray guardians of art
Patrol the halls on spongy shoes,
Impartially protective, though
Perhaps suspicious of Toulouse.

Here dozes one against the wall,
Disposed upon a funeral chair.
A Degas dancer pirouettes
Upon the parting of his hair.

See how she spins! The grace is there,
But strain as well is plain to see.
Degas loved the two together:
Beauty joined to energy.

Edgar Degas purchased once
A fine El Greco, which he kept
Against the wall beside his bed
To hang his pants on while he slept.

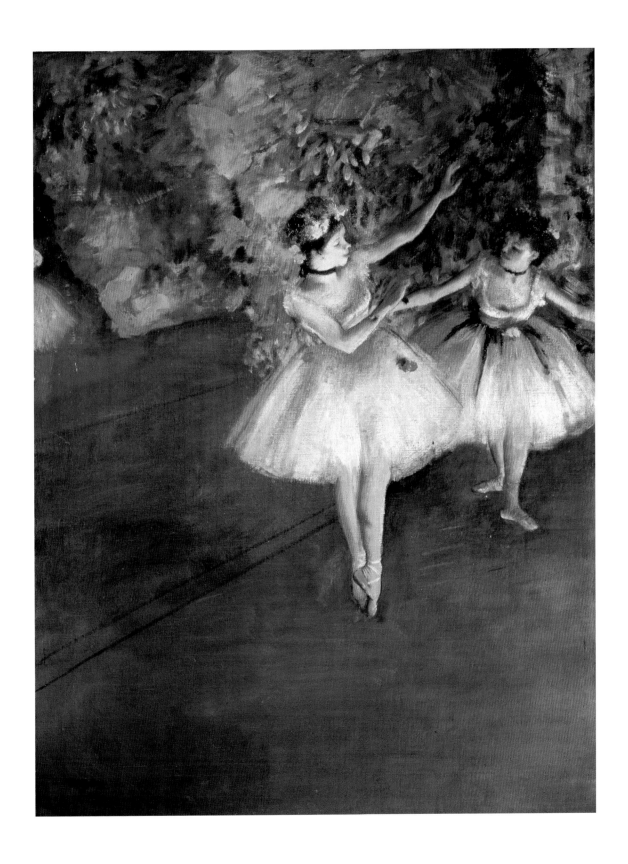

Edgar Degas
Two Dancers on a Stage

Excerpt from

Objects & Apparitions

Octavio Paz

Hexahedrons of wood and glass,
scarcely bigger than a shoebox,
with room in them for night and all its lights.

Monuments to every moment,
refuse of every moment, used:
cages for infinity.

Marbles, buttons, thimbles, dice,
pins, stamps, and glass beads:
tales of the time.

Memory weaves, unweaves the echoes:
in the four corners of the box
shadowless ladies play at hide-and-seek.

Fire buried in the mirror,
water sleeping in the agate:
solos of Jenny Colonne and Jenny Lind.

"One has to commit a painting," said Degas,
"the way one commits a crime." But you constructed
boxes where things hurry away from their names.

. . .

The reflector of the inner eye
scatters the spectacle:
God all alone above an extinct world.

The apparitions are manifest,
their bodies weigh less than light,
lasting as long as this phrase lasts.

Joseph Cornell: inside your boxes
my words became visible for a moment.

(*Translated by Elizabeth Bishop*)

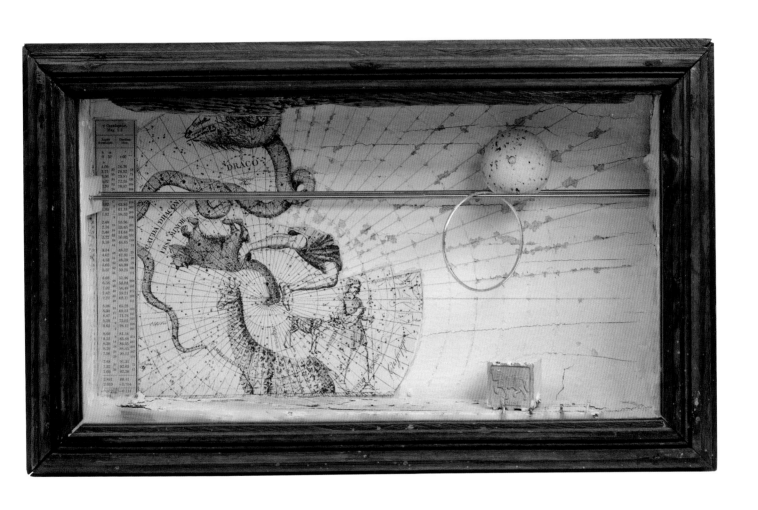

Joseph Cornell
Space Object Box: "Little Bear, etc." motif

Excerpt from

Ode on a Grecian Urn

John Keats

Thou still unravish'd bride of quietness,
 Thou foster-child of silence and slow time,
Sylvan historian, who canst thus express
 A flowery tale more sweetly than our rhyme:
What leaf-fring'd legend haunts about thy shape
 Of deities or mortals, or of both,
 In Tempe or the dales of Arcady?
 What men or gods are these? What maidens loth?
What mad pursuit? What struggle to escape?
 What pipes and timbrels? What wild ecstasy?

Heard melodies are sweet, but those unheard
 Are sweeter; therefore, ye soft pipes, play on;
Not to the sensual ear, but, more endear'd,
 Pipe to the spirit ditties of no tone:
Fair youth, beneath the trees, thou canst not leave
 Thy song, nor ever can those trees be bare;
 Bold Lover, never, never canst thou kiss,
Though winning near the goal yet, do not grieve;
 She cannot fade, though thou hast not thy bliss,
 For ever wilt thou love, and she be fair!

. . .

O Attic shape! Fair attitude! with brede
 Of marble men and maidens overwrought,
With forest branches and the trodden weed;
 Thou, silent form, dost tease us out of thought
As doth eternity: Cold Pastoral!
 When old age shall this generation waste,
 Thou shalt remain, in midst of other woe
Than ours, a friend to man, to whom thou say'st,
 "Beauty is truth, truth beauty,— that is all
 Ye know on earth, and all ye need to know."

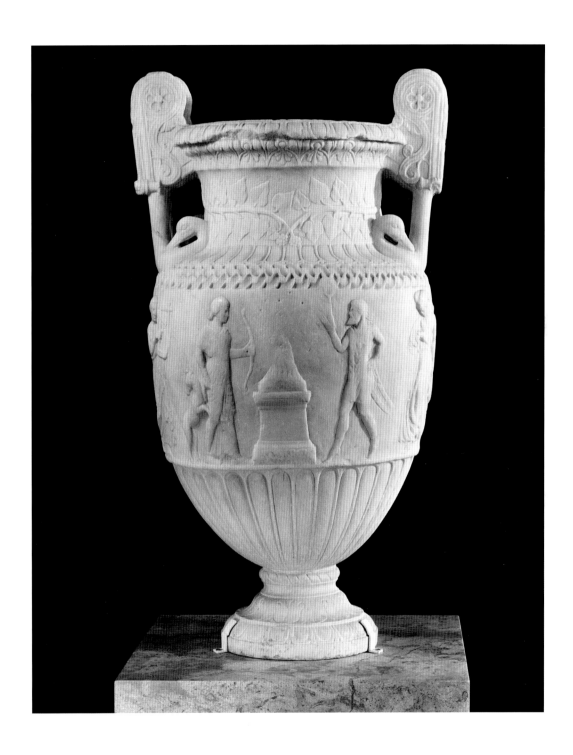

Sosibios vase

Excerpt from

Poem

Elizabeth Bishop

About the size of an old-style dollar bill,

American or Canadian,

mostly the same whites, gray greens, and steel grays

— this little painting (a sketch for a larger one?)

has never earned any money in its life.

Useless and free, it has spent seventy years

as a minor family relic handed along collaterally to owners

who looked at it sometimes, or didn't bother to.

It must be Nova Scotia; only there

does one see gabled wooden houses

painted that awful shade of brown.

. . .

Life and the memory of it cramped,

dim, on a piece of Bristol board,

dim, but how live, how touching in detail

— the little that we get for free,

the little of our earthly trust. Not much.

About the size of our abidance

along with theirs: the munching cows,

the iris, crisp and shivering, the water

still standing from spring freshets,

the yet-to-be-dismanteld elms, the geese.

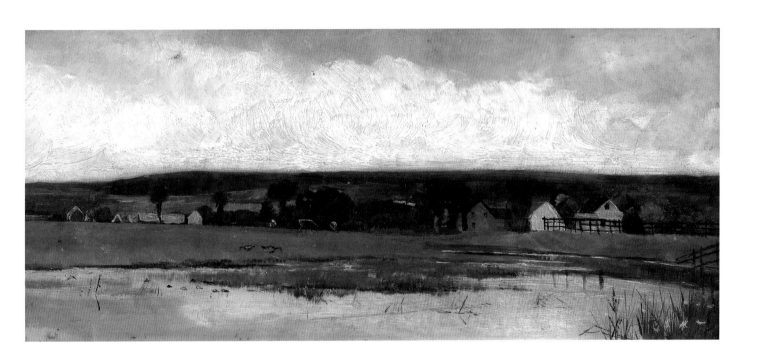

George Hutchinson
Untitled

Stuart Davis: Premier, 1957

X.J. Kennedy

With large and swollen bag of milk.
She stands, this stabled cow.
Black cat pads in on cushioned feet
To raise a loud MEOW.

Now farmer squeezes bag — oh, see
The warm white fluid sluice! —
As fat cat begs for any drop
Of creamy new cow juice.

Well fed, cat purrs, one hundred per
Cent sound asleep, it seems,
While Sandman sprinkles her for free
From his large bag of dreams.

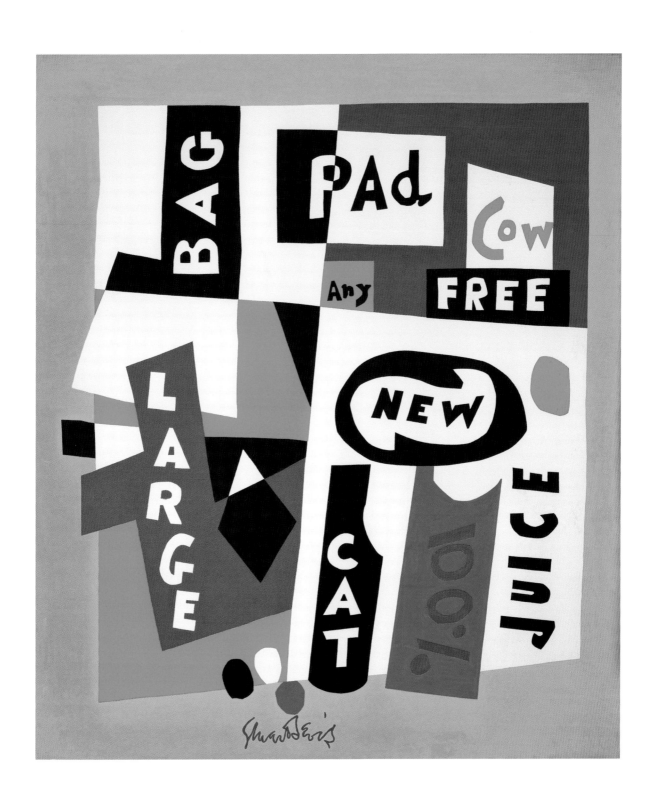

Stuart Davis

Premiere

Roses

Pierre de Ronsard

I send you here a wreath of blossoms blown,
And woven flowers at sunset gathered,
Another dawn had seen them ruined, and shed
Loose leaves upon the grass at random strown.
By this, their sure example, be it known,
That all your beauties, now in perfect flower,
Shall fade as these, and wither in an hour,
Flowerlike, and brief of days, as the flower sown.

Ah, time is flying, lady — time is flying;
Nay, 'tis not time that flies but we that go,
Who in short space shall be in churchyard lying,
And of our loving parley none shall know,
Nor any man consider what we were;
Be therefore kind, my love, whiles thou art fair.

(*Translated by Andrew Lang*)

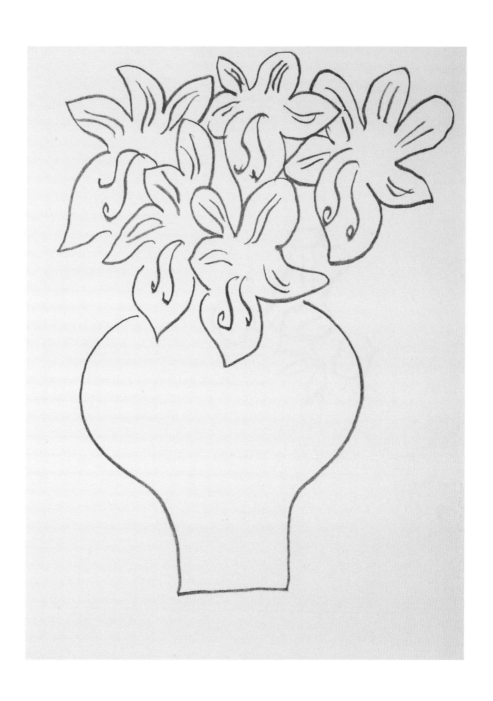

Henri Matisse
Illustration for "Le Passant et le Génie" in
"Florilège des amours de Ronsard"

Spring (The Procession)

Rachel Wetzsteon

And had it come to this?
All winter the leaves clung to the branches
and snow, withheld as an angry god's
or an old globe's accusation, never fell.
Fierce disorder followed: sleds languished;
sidewalks smelled of pine and lilac;
coats hung — dusty, comical — on high pegs.
White was a memory. And when spring came
it was only a name, a fact on a page
without the corresponding colors
that blared their message over town, shouting
You struggled through the cold, hard winter
new bloom on cue: be like me, be this green.

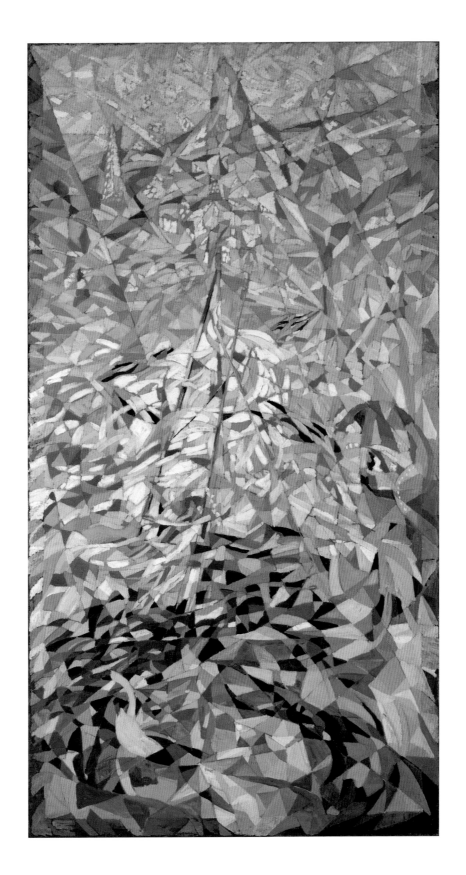

Joseph Stella
Spring (The Procession)

Excerpt from

Sweeney Agonistes

T.S. Eliot

FULL CHORUS:

When you're alone in the middle of the night and

you wake in a sweat and a hell of a fright

When you're alone in the middle of the bed and

you wake like someone hit you on the head

You've had a cream of a nightmare dream and

you've got the hoo-ha's coming to you.

Hoo hoo hoo

You dreamt you waked up at seven o'clock and it's

foggy and it's damp and it's dawn and it's dark

And you wait for a knock and the turning of a lock

for you know the hangman's waiting for you.

And perhaps you're alive

And perhaps you're dead

Hoo ha ha

Hoo ha ha

Hoo

Hoo

Hoo

KNOCK KNOCK KNOCK

KNOCK KNOCK KNOCK

KNOCK

KNOCK

KNOCK

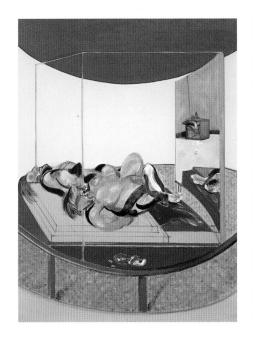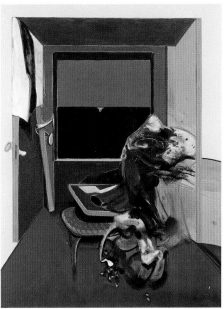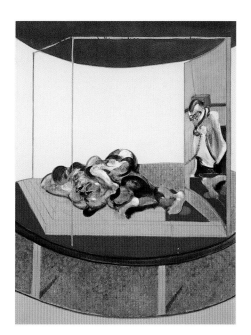

Francis Bacon
Triptyph Inspired by T.S. Eliot

Sunflowers

Robert Fagles

Thank God that I can rise with the sun
reap these flowers rising with the sun
but rush they go so quickly
do them in one rush you must
the buds dense with the gold
opening firmly paint them
ochre to chrome to gold
the petals curl
rounding out now
quick before they wither
take the thrust of the stalk
the heads flung back
exultant
petals stretching stronger
the center
stronger now take hold
of the big shag bloom
The hurling rays
before they burn into umber go to seed
if I can make these flowers mine
their prime my prime
their corona my dark heart
is bursting green to gold
God help me
flower with these flowers
with all their husk and sudden glory
yes I fling my arms to the sun while there is
time
I rise with these great flowers dying into life.

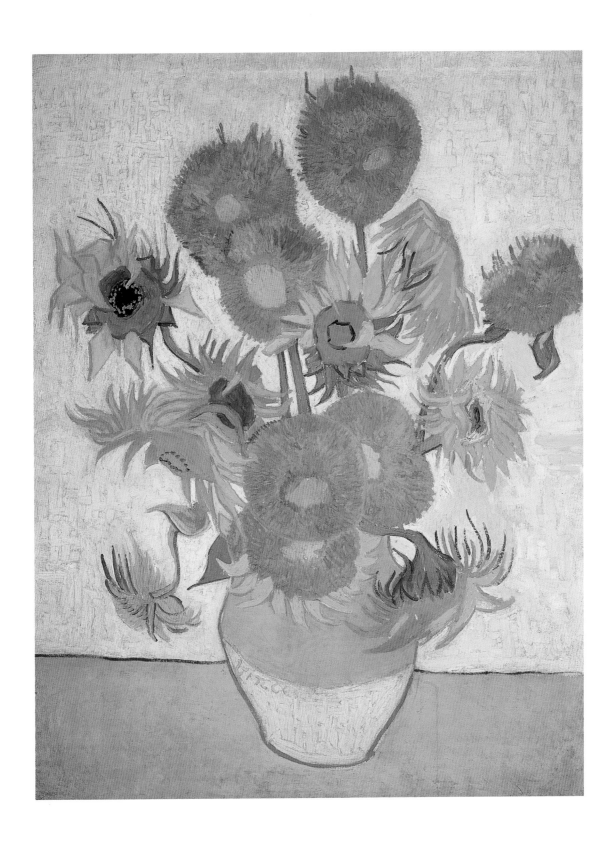

Vincent van Gogh

Fourteen Sunflowers in a Vase

The Car

Jane Freilicher & Kenneth Koch

Choke: I am a bloke. My name is choke.

Wheel: I am a wheel, central feel of the automobile.

Gear: I am a gear. You all fear me.

Tires: I am the tires, a raspberry is filled with sins.

Window: I am a window, I know everything.

Windshield Wiper: I am a wiper of window that shield-wiper.

Crank: I am a crank.

Crankcase: I am a crankcase.

Nurse: Bottoms up.

Transmission: I am the transmission, ever close to you.

Trunk: I am a trunk, full of personality.

Dashboard: I am setting sun, a dashboard.

Clutch: I clutch. We like each other.

Brake: Brake, brake, brake.

Shift: Shifty me you like to see.

Roof: I am roof, the winter's tooth.

Throttle: They call me throttle. Relax everybody.

Backseat: I am the backseat. Climb up and down.

Petroleum: I am petroleum, love's dream.

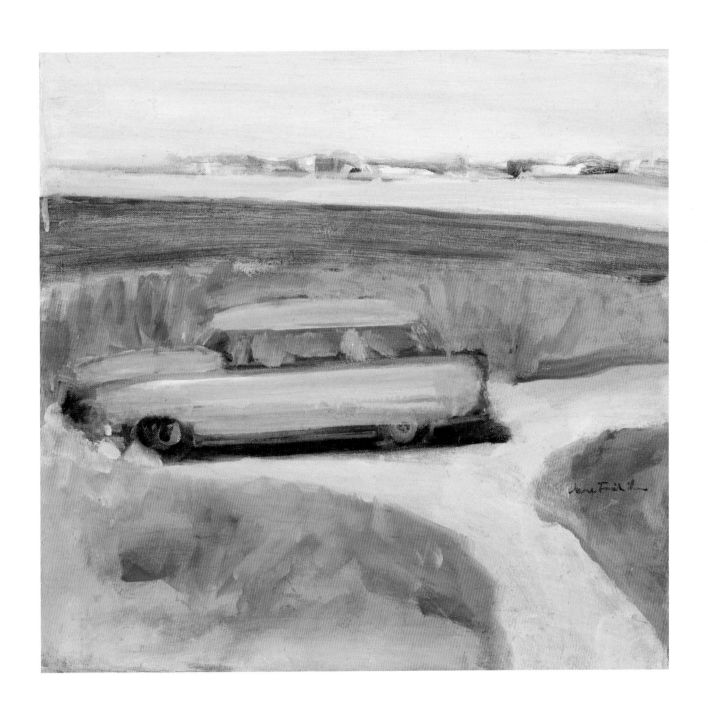

Jane Freilicher
The Car

Excerpt from

The Garden of Earthly Delights

Czesław Miłosz

In the July sun they were leading me to the Prado,
Straight to the room where The Garden of Earthly Delights
Had been prepared for me. So that I run to its waters
And immerse myself in them and recognize myself.
The twentieth century is drawing to its close.
I will be immured in it like a fly in amber.
I was old but my nostrils craved new scents
And through my five senses I received a share in the earth
Of those who led me, our sisters and lovers.
How lightly they walk! Their hips in trousers, not in trailing dresses,
Their feet in sandals, not on cothurni,
Their hair not clasped by a tortoiseshell buckle.
Yet constantly the same, renewed by the moon, Luna,
In a chorus that keeps praising Lady Venus.
Their hands touched my hands and they marched, gracious,
As if in the early morning at the outset of the world.

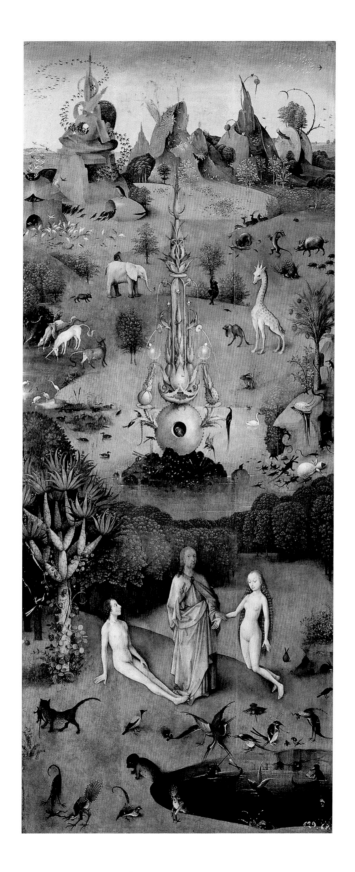

Hieronymus Bosch
The Garden of Earthly Delights (detail)

Excerpt from

The Horizontal Line
(Homage to Agnes Martin)

Edward Hirsch

A horizontal line is a pilgrimage

A segment of devotion wrested from time

An infinitely gentle mark on a blank page

The stripe remains after everything else is gone

It is a wisp of praise with a human hand

It is singing on a bare canvas

Agnes Martin
Friendship

Canto I, The Inferno

Dante Alighieri

Midway along the journey of our life
I woke to find myself in a dark wood,
for I had wandered off from the straight path.
How hard it is to tell what it was like,
this wood of wilderness, savage and stubborn
(the thought of it brings back all my old fears),
a bitter place! Death could scarce be bitterer.
But if I would show the good that came of it
I must talk about things other than the good.

(*Translation by Mark Musa*)

Robert Rauschenberg
"Canto I: The Dark Wood of Error," from the series
"Thirty-four Illustrations for Dante's Inferno"

Excerpt from

The Knight, Death, and the Devil

Randall Jarrell

Cowhorn-crowned, shockheaded, cornshuck-bearded,
Death is a scarecrow — his death's-head a teetotum
That tilts up toward man confidentially
But trimmed with adders; ringlet-maned, rope-bridled,
The mare he rides crops herbs beside a skull.
He holds up, warning, the crossed cones of time:
Here, narrowing into now, the Past and Future
Are quicksand.

 • • •

The death of his own flesh, set up outside him;
The flesh of his own soul, set up outside him —
Death and the devil, what are these to him?
His being accuses him — and yet his face is firm
In resolution, in absolute persistence;
The folds of smiling do for steadiness;
The face is its own fate — a man does what he must —
And the body underneath it says: I am.

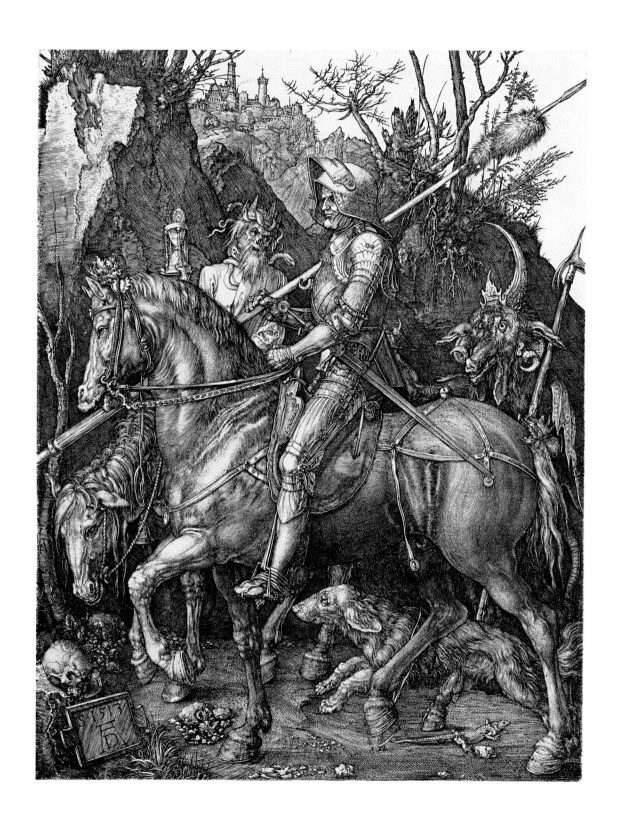

Albrecht Dürer
Knight, Death, and the Devil

Excerpt from

The Temeraire

Herman Melville

The gloomy hulls, in armor grim,
 Like clouds o'er moors have met,
And prove that oak, and iron, and man
 Are tough in fibre yet.
But Splendors wane. The sea-fight yields
 No front of old display;
The garniture, emblazonment,
 And heraldry all decay.
Towering afar in parting light,
 The fleets like Albion's forelands shine —
The full-sailed fleets, the shrouded show
 Of Ships-of-the-Line.
The fighting Temeraire,
 Built of a thousand trees,
Lunging out her lightnings,
 And beetling o'er the seas —

 . . .

But Trafalgar' is over now,
 The quarter-deck undone;
The carved and castled navies fire
 Their evening-gun.
O, Tital Temeraire,
 Your stern-lights fade away;
Your bulwarks to the years must yield,
 And heart-of-oak decay.
A pigmy steam-tug tows you,
 Gigantic, to the shore —
Dismantled of your guns and spars,
 And sweeping wings of war.
The rivets clinch the iron-clads,
 Men learn a deadlier lore;
But Fame has nailed your battle-flags —
 Your ghost it sails before:
O, the navies old and oaken,
 O, the Temeraire no more!

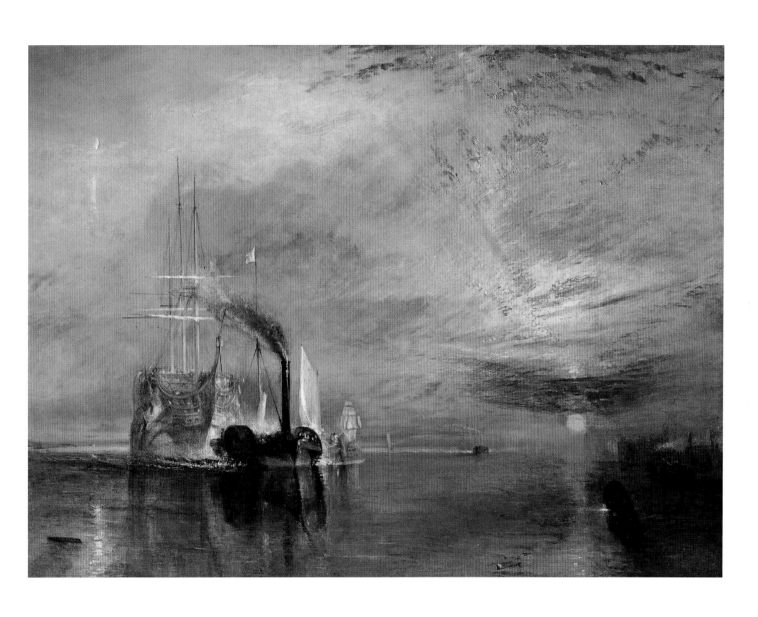

J. M. W. Turner

The Fighting Temeraire

Excerpt from

The Violinist at the Window, 1918

Jorie Graham

After Matisse

here he is now, again, standing at the window, ready to
 look out if asked to
 by his
 time,
 ready to take up again if he
 must, here where the war to end all wars has come
 to an end — for a while — to take up whatever it is
 the spirit
must take up, & what is the melody of
 that, the sustained one note of obligatory
 hope, taken in, like a virus,
 before the body grows accustomed to it and it
 becomes
 natural again — yes breathe it in,
 the intelude,
 the lull in the
 killing — up
 the heart is asked to go, up —
open these heavy shutters now, the hidden order of a belief system
 trickles to the fore,
 it insists you draw closer to
 the railing — lean out —
time stands out there as if mature, blooming, big as day — & is this not an emaciated
 sky, & how
 thin is this
 sensation of time

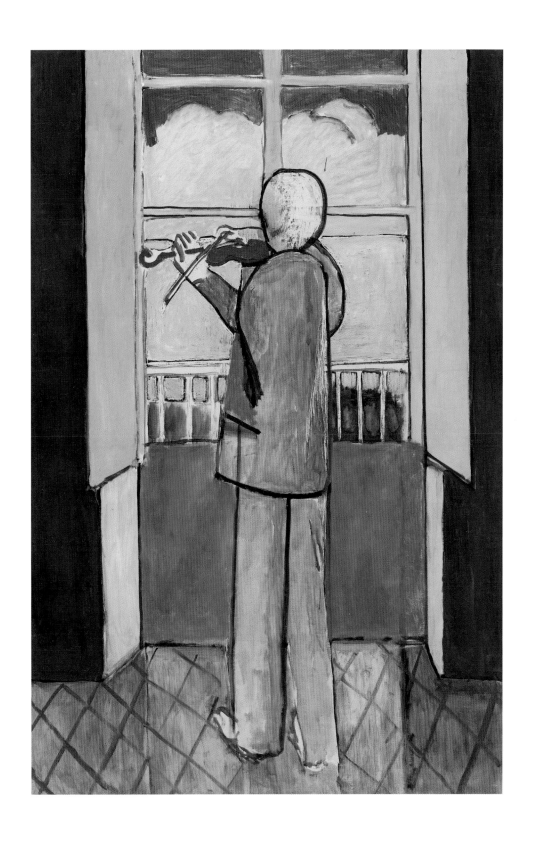

Henri Matisse
The Violinist at the Window (Le Violoniste à la fenêtre)

Excerpt from

Sonnets to Orpheus

Rainer Maria Rilke

But you, divine one singing on the brink of destruction
while legions of forsaken maenads tore at your flesh;
you vanquished their shrieks with harmony, oh bright one,
while from utter devastation rebounded your song afresh.

However they wrestled and raged, seeing you persevere,
they could destroy neither your head nor your lyre;
for each sharp stone they launched at your heart in ire,
turned soft, touching you, acquiring the power to hear.

Whipped on by vengeance, they dismembered you at last,
but your melody resounded intact, in the lion, the boulder,
the bird and the tree. In each of these your song holds fast.

O mournful god forlorn! You inexhaustible trace!
Only because rancor broke and strewed you through nature
have we learned to hear, become the mouth of creation's face.

(*Translated by Robert Hunter*)

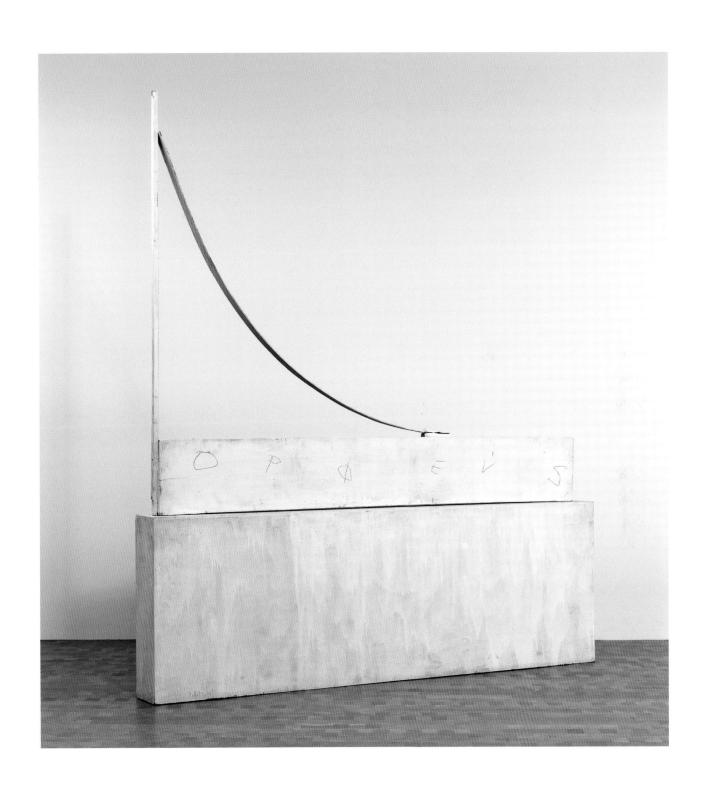

Cy Twombly
Orpheus (Thou Unending Trace)

Excerpt from

To Brooklyn Bridge

Hart Crane

How many dawns, chill from his rippling rest
The seagull's wings shall dip and pivot him,
Shedding white rings of tumult, building high
Over the chained bay waters Liberty —

Then, with inviolate curve, forsake our eyes
As apparitional as sails that cross
Some page of figures to be filed away;
— Till elevators drop us from our day . . .

. . .

O harp and altar, of the fury fused,
(How could mere toil align thy choiring strings!)
Terrific threshold of the prophet's pledge,
Prayer of pariah, and the lover's cry,

Again the traffic lights that skim thy swift
Unfractioned idiom, immaculate sigh of stars,
Beading thy path — condense eternity:
And we have seen night lifted in thine arms.

Under thy shadow by the piers I waited
Only in darkness is thy shadow clear.
The City's fiery parcels all undone,
Already snow submerges an iron year . . .

O Sleepless as the river under thee,
Vaulting the sea, the prairies' dreaming sod,
Unto us lowliest sometime sweep, descend
And of the curveship lend a myth to God.

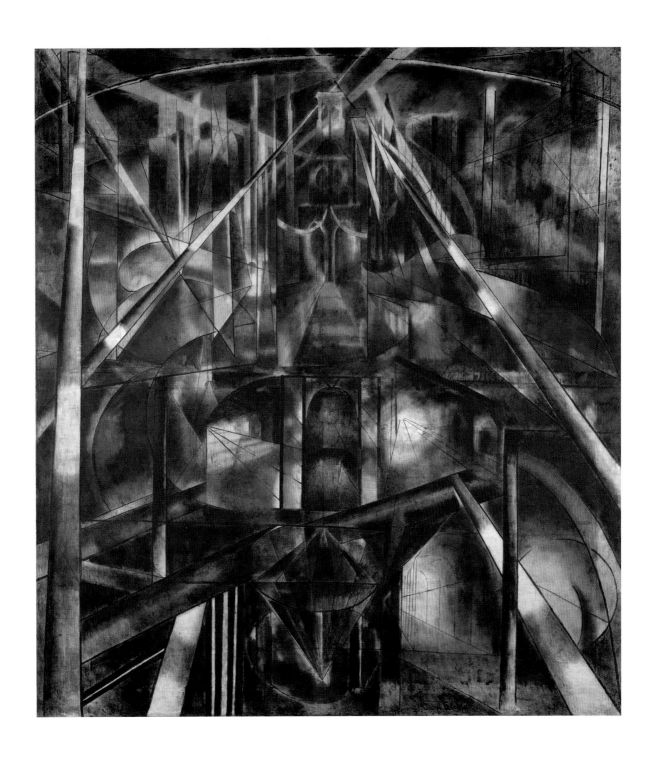

Joseph Stella
Brooklyn Bridge

Van Gogh's Bed

Jane Flanders

is orange,
like Cinderella's coach, like
the sun when he looked it
straight in the eye.

is narrow, he slept alone, tossing
between two pillows, while it carried him
bumpily to the ball.

is clumsy,
but friendly. A peasant
built the frame; and old wife beat
the mattress till it rose like meringue.

is empty,
morning light pours in
like wine, melody, fragrance,
the memory of happiness.

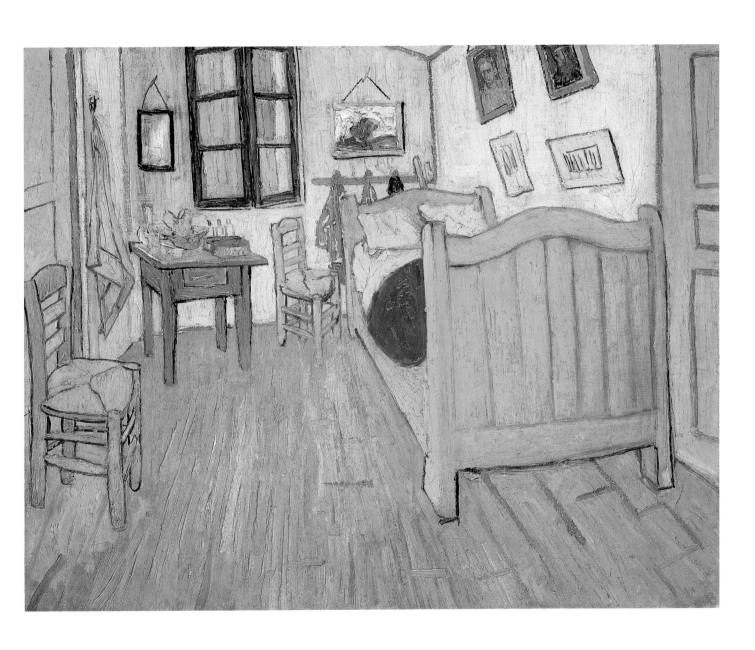

Vincent van Gogh
Bedroom in Arles

Vermeer's Little Girl

Adam Zagajewski

Vermeer's little girl, now famous
watches me. A pearl watches me.
The lips of Vermeer's little girl
are red, moist, and shining.

Oh Vermeer's little girl, oh pearl,
blue turban: you are all light
and I am made of shadow.
Light looks down on shadow
with forbearance, perhaps pity.

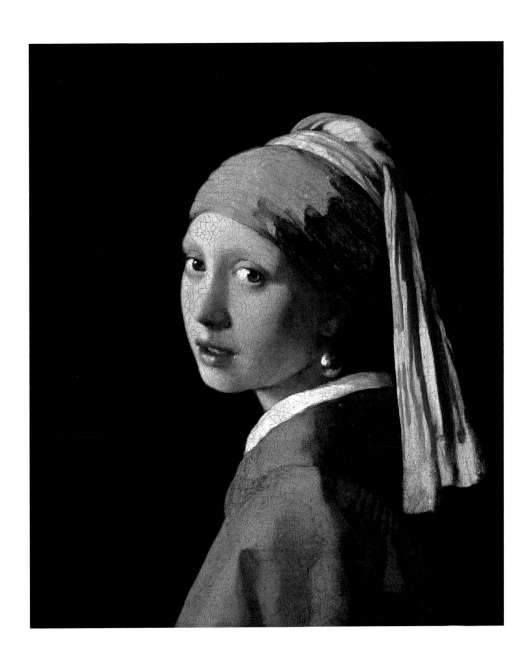

Johannes Vermeer
Girl with a Pearl Earring

What the Water Gave Me (VI)

Pascale Petit

This is how it is at the end —
me lying in my bath
 while the waters break,
my skin glistening with amnion,
 streaks of starlight.

And the waters keep on breaking
as I reverse out of my body.

My life dances on the silver surface
where cacti flower.

The ceiling opens
 and I float up on fire.

Rain pierces me like thorns. I have a steam veil.

I sit bolt upright as the sun's rays embrace me.

Water, you are a lace wedding-gown
I slip over my head, giving birth to my death.

I wear you tightly as I burn —
 don't make me come back.

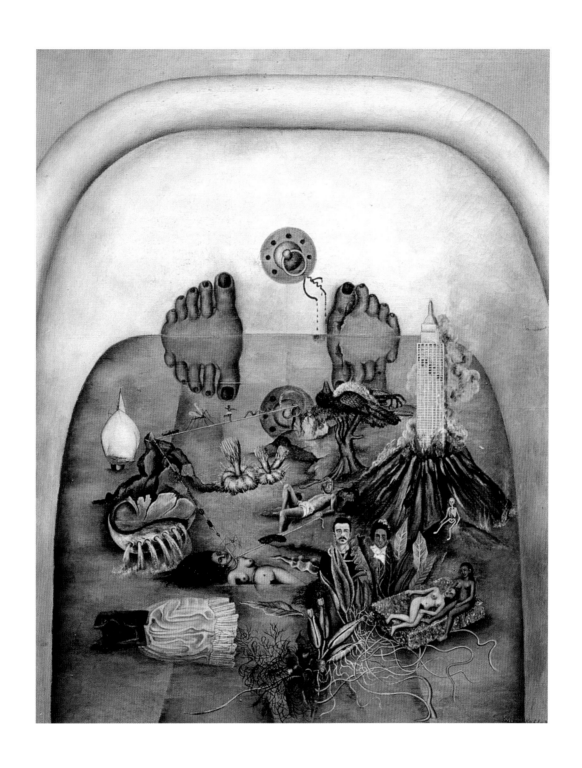

Frida Kahlo
What the Water Gave Me

Excerpt from

The Upanishads

A student asks his master when he will teach him being Zen. So one day master puts an empty cup in front of his student and starts pouring the tea. The cup is full, but the master continues pouring tea and it spills all over the tablecloth. Student tells master that the cup is full. The master responds, "Your cup is also overflowing." Be empty before you receive.

Francesco Clemente
From the Upanishads

The Starry Night

Anne Sexton

That does not keep me from having a terrible
need of — shall I say the word — religion.
Then I go out at night to paint the stars.
 Vincent van Gogh in a letter to his brother

The town does not exist
except where one black-haired tree slips
up like a drowned woman into the hot sky.
The town is silent. The night boils with eleven stars.
Oh starry starry night! This is how
I want to die.

It moves. They are all alive.
Even the moon bulges in its orange irons
to push children, like a god, from its eye.
The old unseen serpent swallows up the stars.
Oh starry starry night! This is how
I want to die:

into that rushing beast of the night,
sucked up by that great dragon, to split
from my life with no flag,
no belly,
no cry.

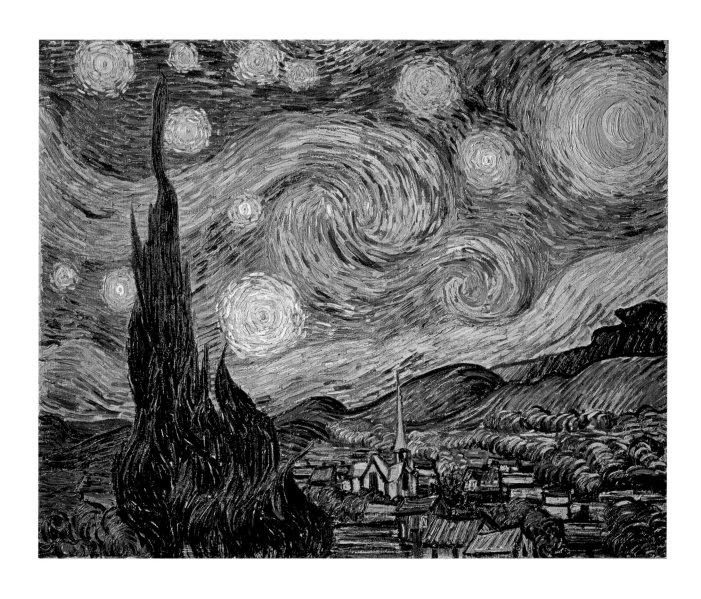

Vincent van Gogh
The Starry Night

Rumi

The wound is the place where the Light enters you.

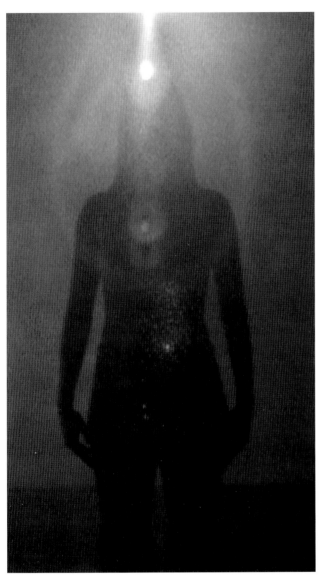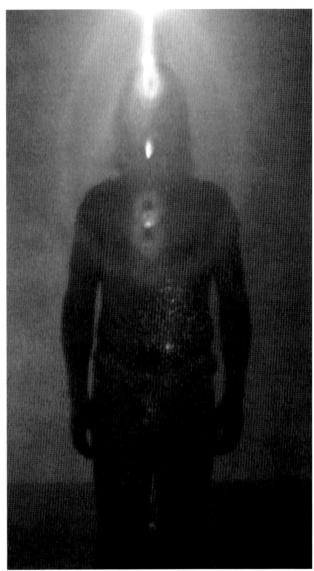

Bill Viola
Bodies of Light

Excerpt from

Self-Portrait in a Convex Mirror

John Ashbery

As Parmigianino did it, the right hand
Bigger than the head, thrust at the viewer
And swerving easily away, as though to protect
What it advertises. A few leaded panes, old beams,
Fur, pleated muslin, a coral ring run together
In a movement supporting the face, which swims
Toward and away like the hand
Except that it is in repose. It is what is
Sequestered.

· · ·

The time of day or the density of the light
Adhering to the face keeps it
Lively and intact in a recurring wave
Of arrival. The soul establishes itself.
But how far can it swim out through the eyes
And still return safely to its nest? The surface
Of the mirror being convex, the distance increases
Significantly; that is, enough to make the point
That the soul is a captive, treated humanely, kept
In suspension, unable to advance much farther
Than your look as it intercepts the picture.

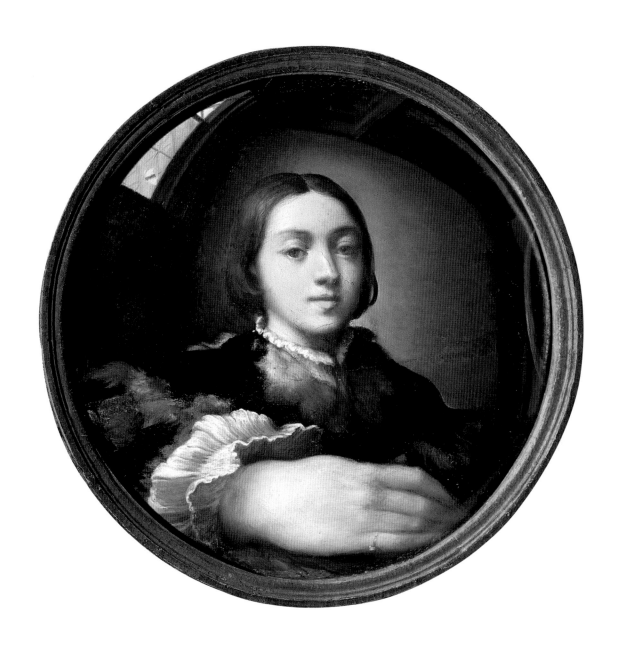

Parmigianino

Self-Portrait in a Convex Mirror

Why I Am Not a Painter

Frank O'Hara

I am not a painter, I am a poet.
Why? I think I would rather be
a painter, but I am not. Well,

for instance, Mike Goldberg
is starting a painting. I drop in.
"Sit down and have a drink" he
says. I drink; we drink. I look
up. "You have SARDINES in it."
"Yes, it needed something there."
"Oh." I go and the days go by
and I drop in again. The painting
is going on, and I go, and the days
go by. I drop in. The painting is
finished. "Where's SARDINES?"
All that's left is just
letters, "It was too much," Mike says.

But me? One day I am thinking of
a color: orange. I write a line
about orange. Pretty soon it is a
whole page of words, not lines.
Then another page. There should be
so much more, not of orange, of
words, of how terrible orange is
and life. Days go by. It is even in
prose, I am a real poet. My poem
is finished and I haven't mentioned
orange yet. It's twelve poems, I call
it ORANGES. And one day in a gallery
I see Mike's painting, called SARDINES.

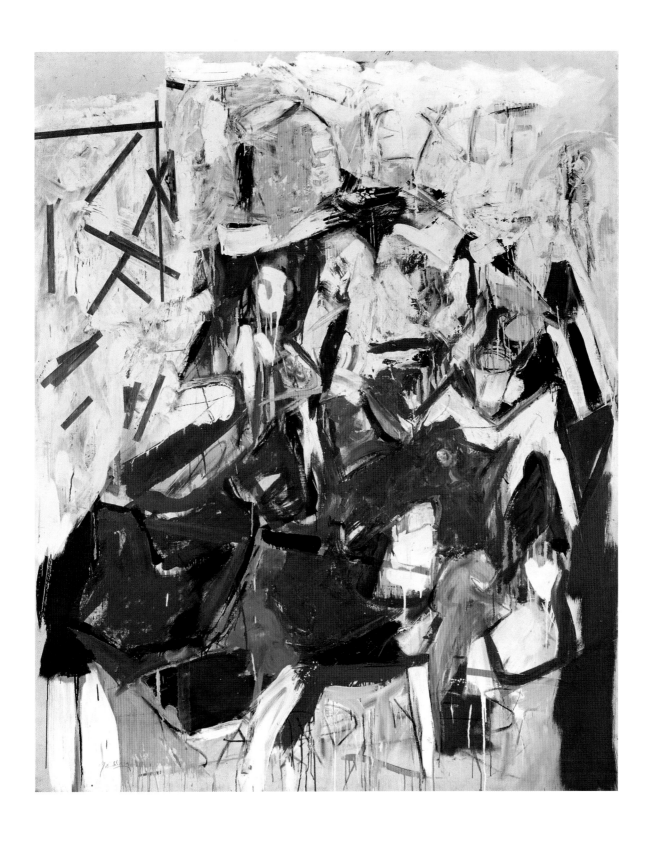

Michael Goldberg

Sardines

On Seeing the Elgin Marbles

John Keats

My spirit is too weak — mortality
 Weighs heavily on me like unwilling sleep,
 And each imagined pinnacle and steep
Of godlike hardship tells me I must die
Like a sick eagle looking at the sky.
 Yet 'tis a gentle luxury to weep
 That I have not the cloudy winds to keep
Fresh for the opening of the morning's eye.
Such dim-conceived glories of the brain
 Bring round the heart an undescribable feud;
So do these wonders a most dizzy pain,
 That mingles Grecian grandeur with the rude
Wasting of old time — with a billowy main —
 A sun — a shadow of a magnitude.

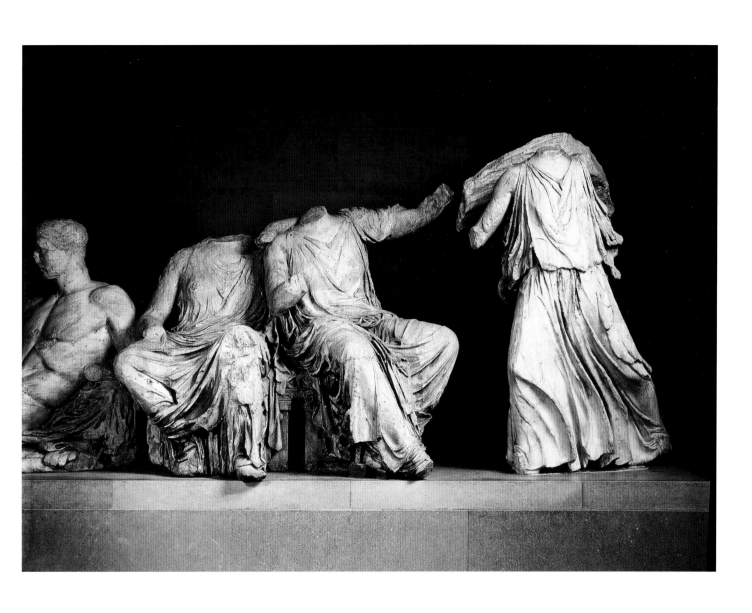

The Elgin Marbles (detail)

Excerpt from

On the Medusa of Leonardo da Vinci in the Florentine Gallery

Percy Bysshe Shelley

It lieth, gazing on the midnight sky,
Upon the cloudy mountain-peak supine;
Below, far lands are seen tremblingly;
Its horror and its beauty are divine.
Upon its lips and eyelids seems to lie
Loveliness like a shadow, from which shine,
Fiery and lurid, struggling underneath,
The agonies of anguish and of death.

Yet it is less the horror than the grace
Which turns the gazer's spirit into stone,
Whereon the lineaments of that dead face
Are graven, till the characters be grown
Into itself, and thought no more can trace;
'Tis the melodious hue of beauty thrown
Athwart the darkness and the glare of pain,
Which humanize and harmonize the strain.

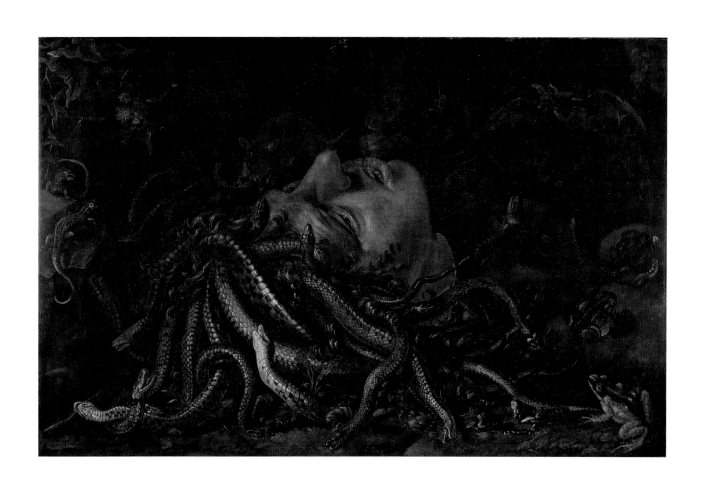

Flemish Painter (previously attributed to Leonardo da Vinci)
Medusa's Head

Excerpt from

The Ninth Elegy (The Duino Elegies)

Rainer Maria Rilke

Why have to be human, and, shunning Destiny,

long for Destiny? . . .

Not because happiness really

exists, that premature profit of imminent loss.

Not out of curiosity, not just to practise the heart,

that could still be there in laurel. . . .

But because being here amounts to so much, because all

this Here and Now, so fleeting, seems to require us and strangely

concern us. Us the most fleeting of all. Just once,

everything, only for once. Once and no more. And we, too,

once. And never again. But this

having been once, though only once,

having been once on earth — can it ever be cancelled?

And so we keep pressing on and trying to perform it,

trying to contain it within our simple hands,

in the more and more crowded gaze, in the speechless heart.

(*Translated by J.B. Leishman and Stephen Spender*)

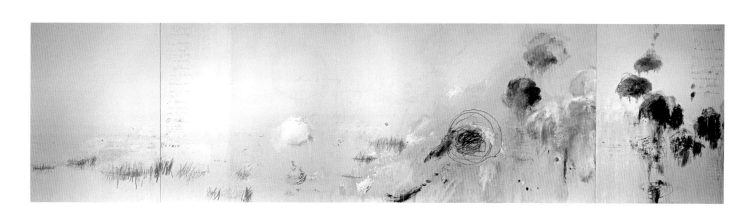

Cy Twombly
Untitled (Say Goodbye, Catullus, to the Shores of Asia Minor)

Excerpt from

For the Union Dead

Robert Lowell

"Relinquunt Omnia Servare Rem Publicam."

The old South Boston Aquarium stands
in a Sahara of snow now. Its broken windows are boarded.
The bronze weathervane cod has lost half its scales.
The airy tanks are dry.

Once my nose crawled like a snail on the glass;
my hand tingled
to burst the bubbles
drifting from the noses of the cowed, compliant fish.

My hand draws back. I often sigh still
for the dark downward and vegetating kingdom
of the fish and reptile. One morning last March,
I pressed against the new barbed and galvanized

fence on the Boston Common. Behind their cage,
yellow dinosaur steamshovels were grunting
as they cropped up tons of mush and grass
to gouge their underworld garage.

Parking spaces luxuriate like civic
sandpiles in the heart of Boston.
A girdle of orange, Puritan-pumpkin colored girders
braces the tingling Statehouse,

shaking over the excavations, as it faces Colonel Shaw
and his bell-cheeked Negro infantry
on St. Gaudens' shaking Civil War relief,
propped by a plank splint against the garage's earthquake.

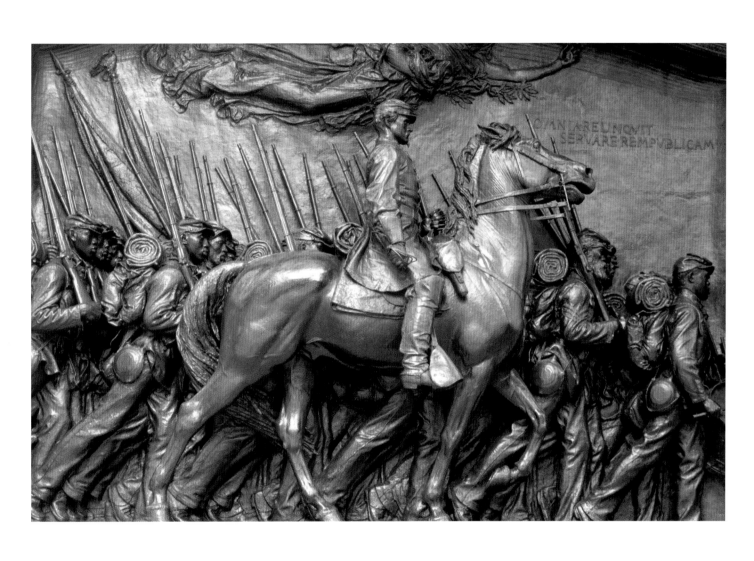

Augustus Saint-Gaudens

Memorial to Robert Gould Shaw and the 54th Massachusetts

Volunteer Infantry Regiment

Vermeer

Wisława Szymborska

As long as the woman from Rijksmuseum
in painted silence and concentration
day after day pours milk
from the jug to the bowl,
the World does not deserve
the end of the world.

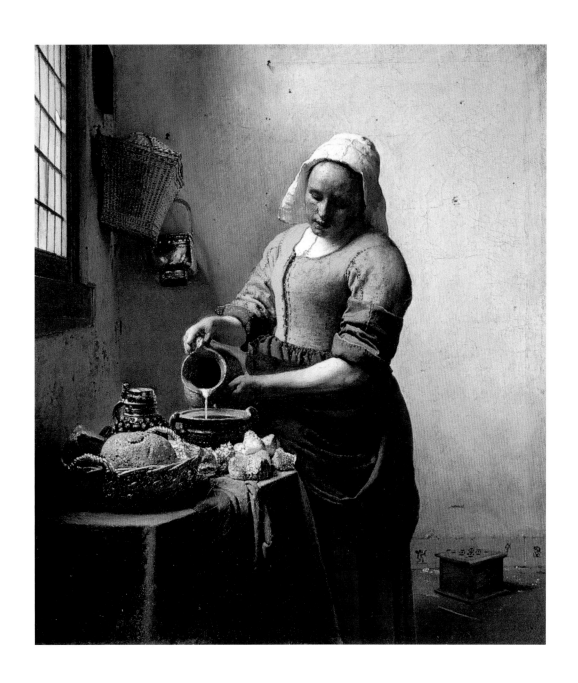

Johannes Vermeer
The Milkmaid

Excerpt from

Hamlet

William Shakespeare

QUEEN GERTRUDE:

There is a willow grows aslant a brook,

That shows his hoar leaves in the glassy stream;

There with fantastic garlands did she come

Of crow-flowers, nettles, daisies, and long purples

That liberal shepherds give a grosser name,

But our cold maids do dead men's fingers call them:

There, on the pendent boughs her coronet weeds

Clambering to hang, an envious sliver broke;

When down her weedy trophies and herself

Fell in the weeping brook. Her clothes spread wide;

And, mermaid-like, awhile they bore her up:

Which time she chanted snatches of old tunes;

As one incapable of her own distress,

Or like a creature native and indued

Unto that element: but long it could not be

Till that her garments, heavy with their drink,

Pull'd the poor wretch from her melodious lay

To muddy death.

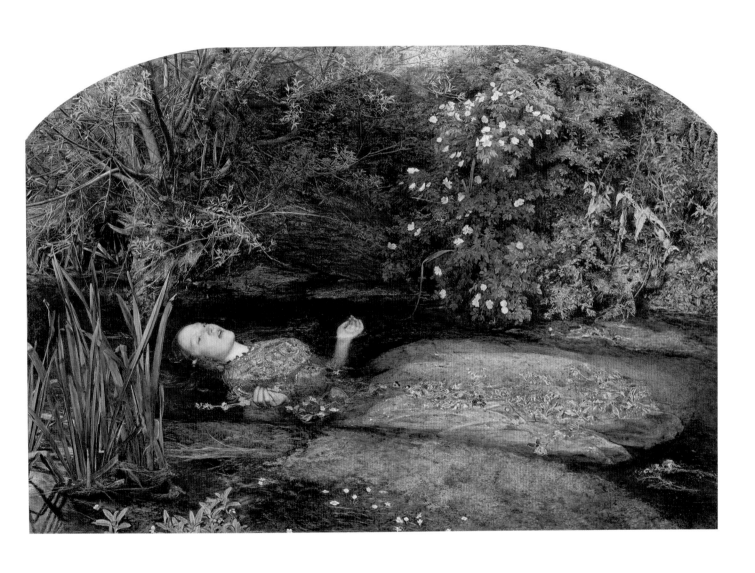

Sir John Everett Millais
Ophelia

Winter Landscape

John Berryman

The three men coming down the winter hill
In brown, with tall poles and a pack of hounds
At heel, through the arrangement of the trees,
Past the five figures at the burning straw,
Returning cold and silent to their town,

Returning to the drifted snow, the rink
Lively with children, to the older men,
The long companions they can never reach,
The blue light, men with ladders, by the church
The sledge and shadow in the twilit street,

Are not aware that in the sandy time
To come, the evil waste of history
Outstretched, they will be seen upon the brow
Of that same hill: when all their company
Will have been irrecoverably lost,

These men, this particular three in brown
Witnessed by birds will keep the scene and say
By their configuration with the trees,
The small bridge, the red houses and the fire,
What place, what time, what morning occasion

Sent them into the wood, a pack of hounds
At heel and the tall poles upon their shoulders,
Thence to return as now we see them and
Ankle-deep in snow down the winter hill
Descend, while three birds watch and the fourth flies.

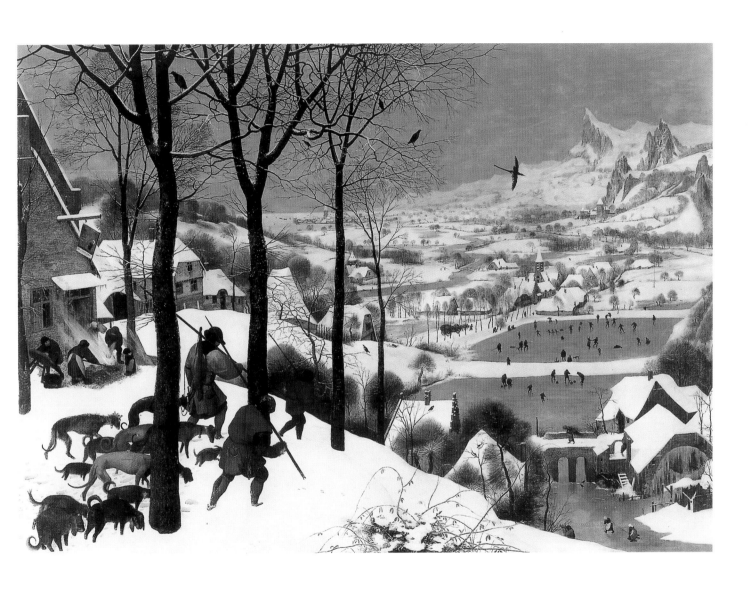

Pieter Brueghel the Elder
Hunters in the Snow

To Marc Chagall

Paul Éluard

Donkey or cow, cockerel or horse
On to the skin of a violin
A singing man a single bird
An agile dancer with his wife

A couple drenched in their youth

The gold of the grass lead of the sky
Separated by azure flames
Of the health-giving dew
The blood glitters the heart rings

A couple the first reflection

And in a cellar of snow
The opulent vine draws
A face with lunar lips
That never slept at night.

(*Translated by Stephen Spender and Frances Cornford*)

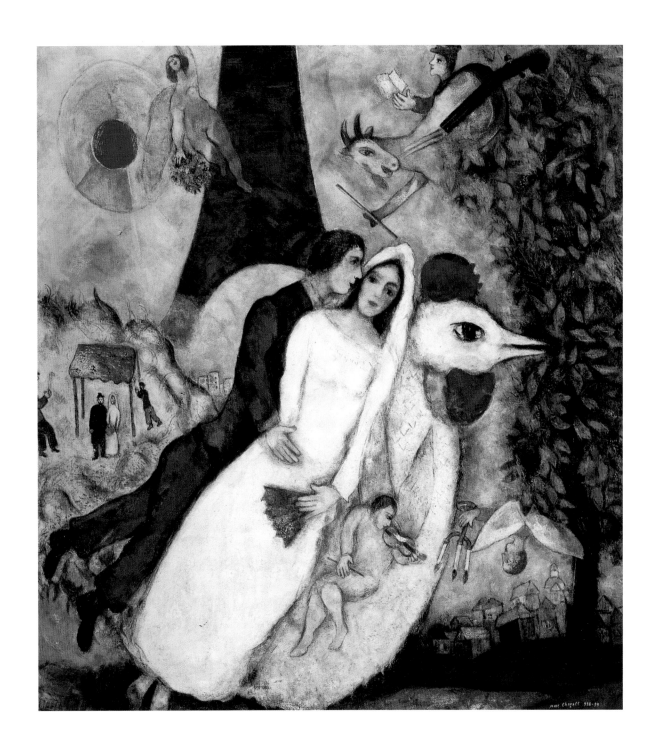

Marc Chagall
The Bride

On Seeing Larry Rivers'
Washington Crossing the Delaware
at the Museum of Modern Art

Frank O'Hara

Now that our hero has come back to us
in his white pants and we know his nose
trembling like a flag under fire,
we see the calm cold river is supporting
our forces, the beautiful history.

To be more revolutionary than a nun
is our desire, to be secular and intimate
as, when sighting a redcoat, you smile
and pull the trigger. Anxieties
and animosities, flaming and feeding

on theoretical considerations and
the jealous spiritualities of the abstract
the robot? they're smoke, billows above
the physical event. They have burned up.
See how free we are! as a nation of persons.

Dear father of our country, so alive
you must have lied incessantly to be
immediate, here are your bones crossed
on my breast like a rusty flintlock,
a pirate's flag, bravely specific

and ever so light in the misty glare
of a crossing by water in winter to a shore
other than that the bridge reaches for.
Don't shoot until, the white of freedom glinting
on your gun barrel, you see the general fear.

Larry Rivers
Washington Crossing the Delaware

The Dance

William Carlos Williams

In Brueghel's great picture, The Kermess,
the dancers go round, they go round and
around, the squeal and the blare and the
tweedle of bagpipes, a bugle and fiddles
tipping their bellies (round as the thick-
sided glasses whose wash they impound)
their hips and their bellies off balance
to turn them. Kicking and rolling
about the Fair Grounds, swinging their butts, those
shanks must be sound to bear up under such
rollicking measures, prance as they dance
in Brueghel's great picture, The Kermess.

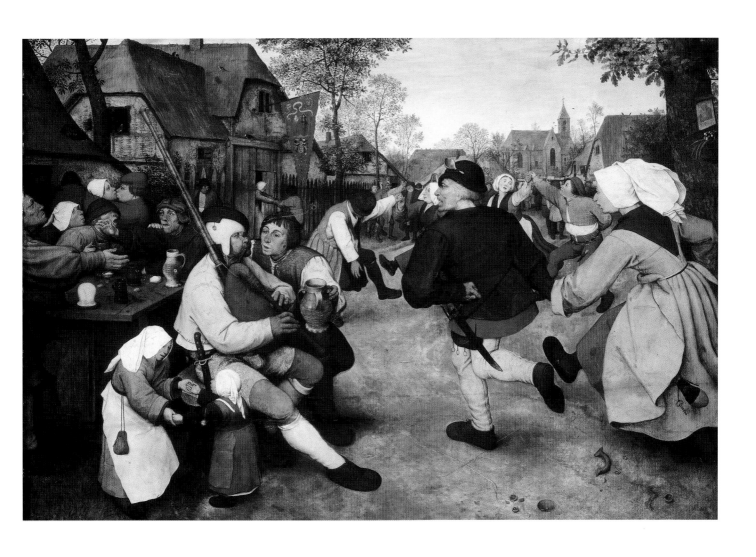

Pieter Brueghel the Elder
The Peasant Dance

Hills, South Truro

Ernest Farrés

I climbed to the very top of the mountain
to speak to myself. You know,
about the present, the future.
 Bared to the sun,
I held the prerogative
of seeing many things coming to pass.
It must be due to the scent of earth
and distant sea, which were consoling.
It must be due to birdsong. It must be
due to trains. Is it due to the grandeur
of this vista?
 As the sun
beat down I allowed my gaze to range
and understood my limits and that a slew
of pot-boilers hinders me. That I am diverted
by punk points of light. That I dedicate
no immortality to doing nothing.
That I hear a whisper from inside.

I say not a word and the surrounding world
suddenly possesses me and bears me away.
I grow lighter. Become leaf-bearing
and even burst into bloom. From the peak
I delight in the superhuman
contemplation of dominions.

But thereafter my lot will be
to descend to the plain, returning
to my kind, and thus, as if I were such,
I shall resume an everyday likeness
squandering time and resources.

(*Translated by Lawrence Venuti*)

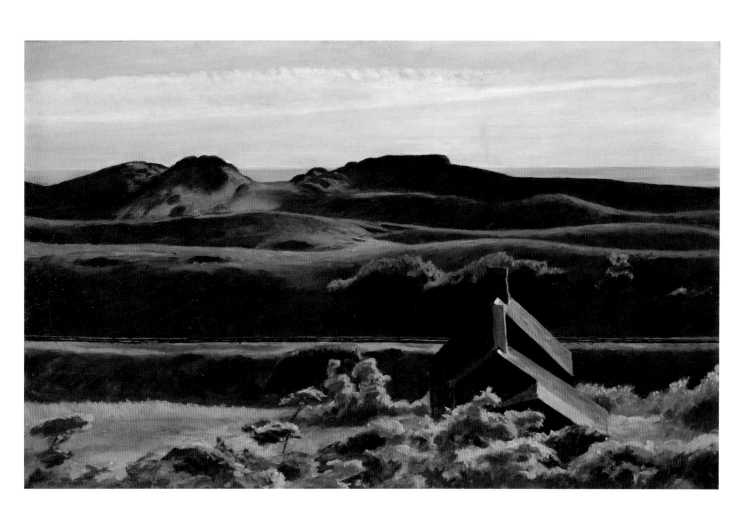

Edward Hopper
Hills, South Truro

Actaeon

Georges Szirtes

O, my America, my Newfoundland
John Donne, "Elegy 20"

O, my America, discovered by slim chance,
behind, as it seemed, a washing line
I shoved aside without thinking —
does desire have thoughts or define
its object, consuming all in a glance?

You, with your several flesh sinking
upon itself in attitudes of hurt,
while the dogs at my heels
growl at the strange red shirt
under a horned moon, you, drinking

night water — tell me what the eye steals
or borrows. What can't we let go
without protest? My own body turns
against me as I sense it grow
contrary. Whatever night reveals

is dangerously toothed. And so the body burns
as if torn by sheer profusion of skin
and cry. It wears its ragged dress
like something it once found comfort in,
the kind of comfort even a dog learns

by scent. So flesh falls away, ever less
human, like desire itself, though pain
still registers in the terrible balance
the mind seems so reluctant to retain,
o, my America, my nakedness!

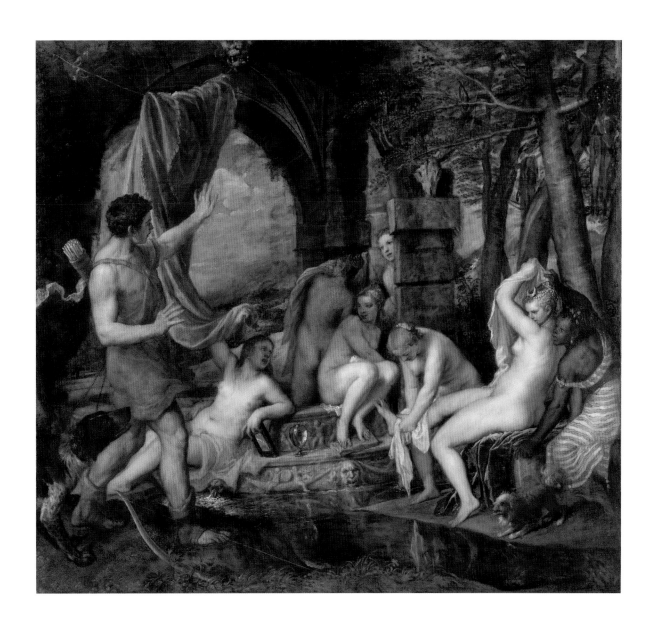

Titian

Diana and Actaeon

Girl Powdering Her Neck

Cathy Song

The light is the inside
sheen of an oyster shell,
sponged with talc and vapor,
moisture from a bath.

A pair of slippers
are placed outside
the rice-paper doors.
She kneels at a low table
in the room,
her legs folded beneath her
as she sits on a buckwheat pillow.

Her hair is black
with hints of red,
the color of seaweed
spread over rocks.

Morning begins the ritual
wheel of the body,
the application of translucent skins.
She practices pleasure:
the pressure of three fingertips
applying powder.
Fingerprints of pollen
some other hand will trace.

The peach-dyed kimono
patterned with maple leaves
drifting across the silk,
falls from right to left
in a diagonal, revealing
the nape of her neck
and the curve of a shoulder
like the slope of a hill
set deep in snow in a country
of huge white solemn birds.
Her face appears in the mirror,
a reflection in a winter pond,
rising to meet itself.

She dips a corner of her sleeve
like a brush into water
to wipe the mirror;
she is about to paint herself.
The eyes narrow
in a moment of self-scrutiny.
The mouth parts
as if desiring to disturb
the placid plum face;
break the symmetry of silence.
But the berry-stained lips,
stenciled into the mask of beauty,
do not speak.

Two chrysanthemums
touch in the middle of the lake
and drift apart.

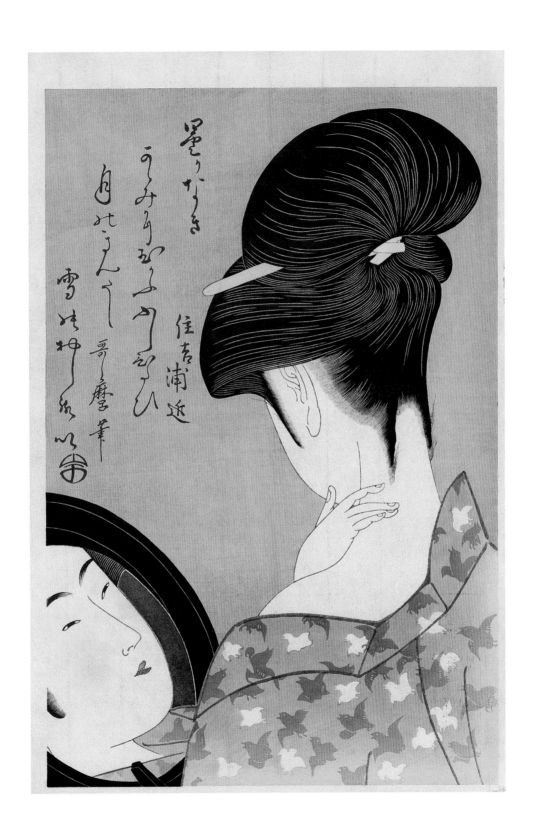

Kitagawa Utamaro

Girl Powdering Her Neck

For Mark Rothko

Jorie Graham

Shall I say it is the constancy of persian red
that permits me to see
this persian red bird
come to sit now
on the brick barbecue
within my windowframe. Red,

on a field made crooked
as with disillusion or faulty
vision, a backyard in winter
that secretly seeks a bird. He has
a curiosity
that makes him slightly awkward,

as if just learning
something innate, and yet
there is no impatience,

 just that pose of his
 once between each move
 as if to say, and is *this* pleasing?

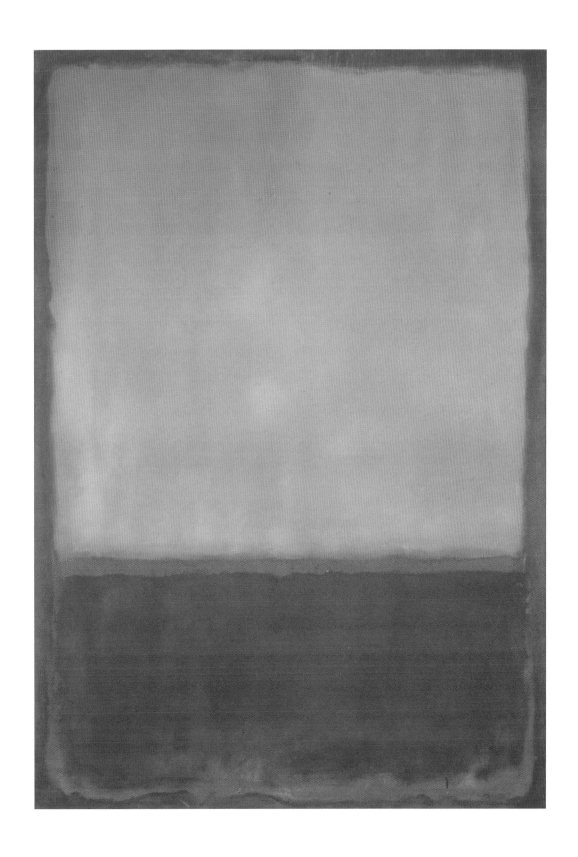

Mark Rothko
Ochre and Red on Red

To One Who Is Too Gay

Charles Baudelaire

Your head, your bearing, your gestures
Are fair as a fair countryside;
Laughter plays on your face
Like a cool wind in a clear sky.

The gloomy passer-by you meet
Is dazzled by the glow of health
Which radiates resplendently
From your arms and shoulders.

The touches of sonorous color
That you scatter on your dresses
Cast into the minds of poets
The image of a flower dance.

Those crazy frocks are the emblem
Of your multi-colored nature;
Mad woman whom I'm mad about,
I hate and love you equally!

At times in a lovely garden
Where I dragged my atony,
I have felt the sun tear my breast,
As though it were in mockery;

Both the springtime and its verdure
So mortified my heart
That I punished a flower
For the insolence of Nature.

Thus I should like, some night,
When the hour for pleasure sounds,
To creep softly, like a coward,
Toward the treasures of your body,

To whip your joyous flesh
And bruise your pardoned breast,
To make in your astonished flank
A wide and gaping wound,

And, intoxicating sweetness!
Through those new lips,
More bright, more beautiful,
To infuse my venom, my sister!

(*Translated by William Aggeler*)

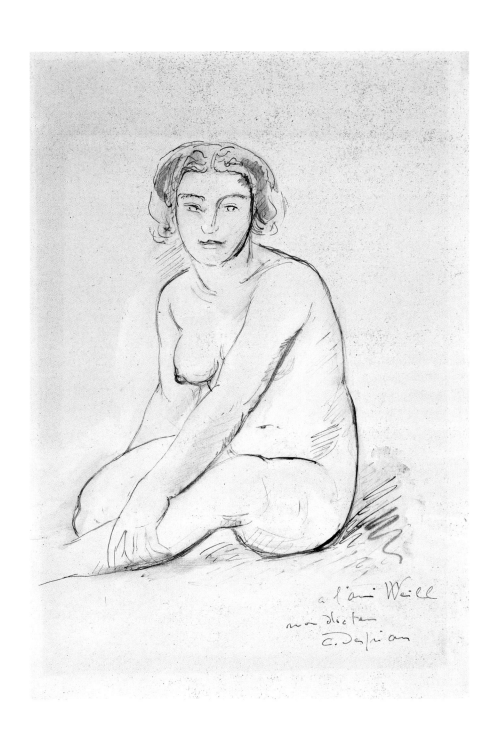

Charles Despiau

Illustration for "Poemes" by Charles Baudelaire

At the Frick

Anthony Hecht

Before a grotto of blue-tinted rock
Master Bellini has set down St. Francis.
A light split through the Apennines to lock,
Counter, and splice man's painful doubleness.
Else he could weakly couple at the belt
His kite-mind to his cloven nether parts
That seek to dance their independent dances.
The sudden light descending came to bless
His hands and feet with blisters, and to melt
With loving that most malleable of hearts.

Birds in the trees his chronicles recite:
How that God made of him a living net
To catch all graces, yet to let through light.
Fisher of birds and lepers, lost in thought,
Darkly emblazoned, where the oblivious mule
Champs at the grasses and the sunset rusts
The hilltop fortress, where the painter set
Heron and rabbit, it was here he caught
Holiness that came swimming like a school
Of silver fishes to outlast his lusts.

Now I have seen those mountains, and have seen
The fawn go frozen on the road with fear
Of the careening autobus, the sheen
Of its dilated eyes flash in its head
Like glass reflectors, and have seen the trees
As green as ever where their braches thresh
The warm Italian winds of one more year
Since that great instant. The painter's dead
Who brought the Doge and nobles to the knees
Of the wind's Brother Francis in the flesh.

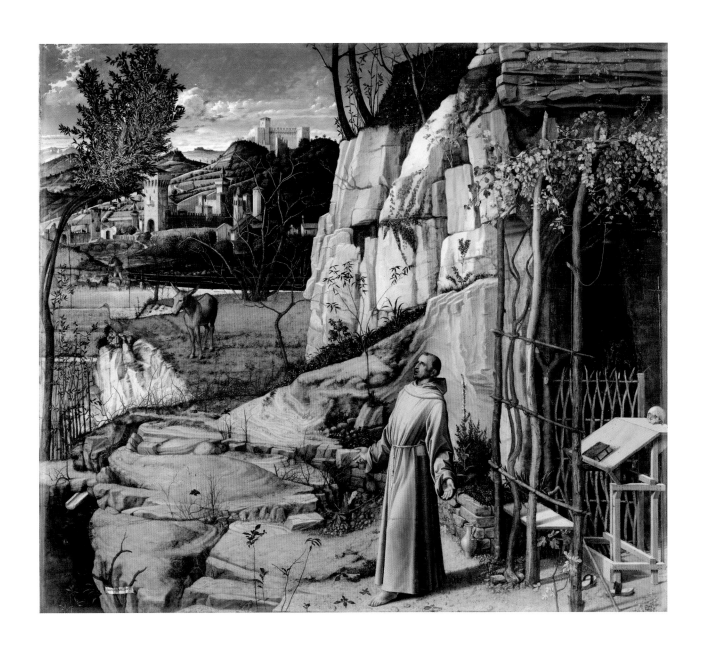

Giovanni Bellini

St. Francis of Assisi in the Desert

Excerpt from

A Few Days

James Schuyler

Today is tomorrow, it's that dead time again: three in the afternoon
 under scumbled clouds . . .
It's cool
 for August and I
can't nail the days down. They go by like escalators, each alike,
 each with its own
message of tears and laughter.

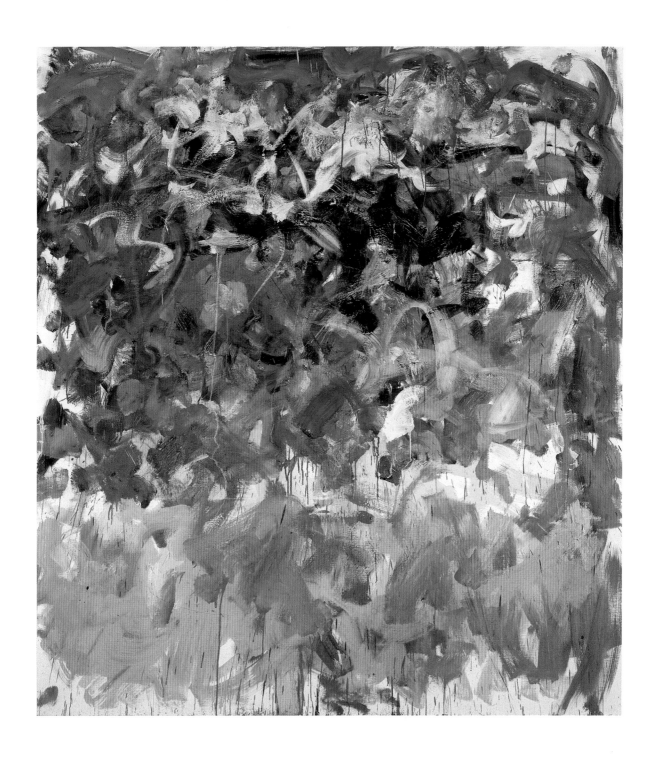

Joan Mitchell

A Few Days I (After James Schuyler)

Excerpt from

In Memory of My Feelings

Frank O'Hara

My quietness has a man in it, he is transparent

and he carries me quietly, like a gondola, through the streets.

He has several likenesses, like stars and years, like numerals.

My quietness has a number of naked selves,

so many pistols I have borrowed to protect myselves

from creatures who too readily recognize my weapons

and have murder in their heart!

 though in winter

they are warm as roses, in the desert

taste of chilled anisette.

 At times withdrawn,

I rise into the cool skies

and gaze on at the imponderable world with the simple identification

of my colleagues, the mountains.

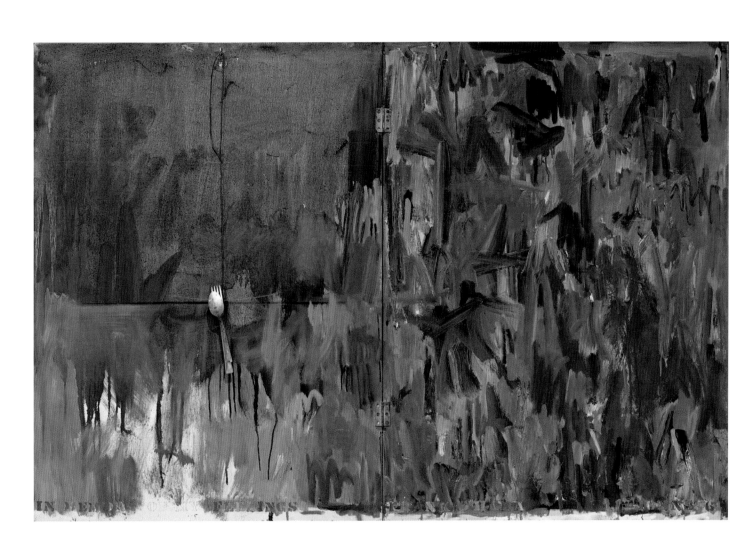

Jasper Johns
In Memory of My Feelings

List of Illustrations and Poems

Page: 38-39
PABLO PICASSO, *Guernica*, 1937
Oil on canvas, 349.3 x 776.6 cm
Prado Madrid
"Guernica" by NORMAN ROSTEN

Page 40-41
HENRI MATISSE, *"Le Guignon" from "Poésies de Stéphane Mallarmé"*
Albert Skira & Cie., Lausanne, 1932.
Photo: Archives H. Matisse
"The Jinx" by STÉPHANE MALLARMÉ

Page 42-43
EDGAR DEGAS, *Two Dancers on a Stage*, c. 1874
61.5 x 46 cm
Photo: Samuel Courtauld Trust, The Courtauld Gallery, London, UK /
Bridgeman Images
"Museum Piece" by RICHARD WILBUR
from *New and Collected Poems*, copyright © 1985 by Richard Wilbur.
Reprinted by permission of Houghton Mifflin Harcourt Publishing
Company. All rights reserved.

Page 44-45
JOSEPH CORNELL, *Space Object Box: "Little Bear, etc." motif*,
mid-1950s-early 1960s
Box construction, 11 x 17 1/2 x 5 1/4 in.
New York, Solomon R. Guggenheim Museum.
Photo: 2015. The Solomon R. Guggenheim Foundation/Art Resource,
NY/ Scala, Florence
Excerpt from "Objections & Apparitions" by OCTAVIO PAZ, translated
by Elizabeth Bishop, from *Poems* by Elizabeth Bishop.
Copyright © 2011 by The Alice H. Methfessel Trust. Publisher's
Note and compilation copyright © 2011 by Farrar, Straus & Giroux.
Reprinted in the United Kingdom by permission of Chatto & Windus,
an imprint of Random House UK.

Page 46-47
Sosibios vase
Paris, Musée du Louvre, Inventory Number: MR987,N1686,MA442
Photo: bpk / Musée du Louvre, Dist. RMN – Grand Palais / Christian
Larrieu
"Ode on a Grecian Urn" by JOHN KEATS

Page 48-49
GEORGE HUTCHINSON, *Untitled*
Oil on masonite, 4 3/16 x 9 11/16 in.
Photo: Robert Lorenzson, New York
Excerpt from "Poem" by ELIZABETH BISHOP from *Poems*.
Copyright © 2011 by The Alice H. Methfessel Trust.
Publisher's Note and compilation copyright © 2011 by Farrar, Straus &
Giroux, LLC.

Page 50-51
STUART DAVIS, *Premiere*, 1957
Oil on canvas, 58 x 50 in.
Los Angeles County Museum of Art (LACMA), Museum Purchase, Art
Museum Council Fund (M.60.4)
Photo: 2015. Digital Image Museum Associates/LACMA/Art Resource
NY/Scala, Florence
"Stuart Davis: Premier, 1957" by X.J. KENNEDY
from *Heart to Heart*, copyright © 2001 by Abrams. Reprinted by
permission of the author.

Page 52-53
HENRI MATISSE, *Illustration for "Le Passant et le Génie" in
"Florilège des amours de Ronsard"*
Albert Skira, Paris, 1948
Photo: Archives H. Matisse
"Roses" by PIERRE DE RONSARD

Page 54-55
JOSEPH STELLA, *Spring (The Procession)*, c. 1914–16
Photo: Yale University Art Gallery
"Spring (The Procession)" by RACHEL WETZSTEON
from *Sakura Park*, copyright © 2006 by Rachel Wetzsteon. Reprinted
with the permission of Persea Books, Inc. (New York),
www.perseabooks.com.

Page 56-57
FRANCIS BACON, *Triptych Inspired by T.S. Eliot*, 1967
Oil on canvas, each 198 × 147 cm
Hirshhorn Museum and Sculpture Garden, Smithsonian Institution,
Washington D.C.
"Sweeney Agonistes" by T.S. ELIOT

Page 58-59
VINCENT VAN GOGH, *Fourteen Sunflowers in a Vase*, 1889
100.5 x 76.5 cm
Tokyo, Yasuda Insurance
Photo: Christie's Images Ltd – ARTOTHEK
"Sunflowers" by ROBERT FAGLES
from *I, Vincent: Poems from the Pictures of Van Gogh*, copyright © 1978
by Princeton University Press. Reprinted by permission of Georges
Borchardt, Inc.

Page 60-61
JANE FREILICHER, *The Car*, 1963
Oil on linen, 18 x 19 in.
Private collection
Photo: Courtesy Tibor de Nagy Gallery, New York
"The Car" by JANE FREILICHER & KENNETH KOCH
Reprinted with the permission of the Kenneth Koch Literary Estate.

Page 86-87
VINCENT VAN GOGH, *The Starry Night*, 1889
Oil on canvas, 73.7 × 92.1 cm
Photo: akg-images, Erich Lessing
"The Starry Night" by ANNE SEXTON
from *All My Pretty Ones*, copyright © 1962 by Anne Sexton, renewed
1990 by Linda G. Sexton. Reprinted by permission of Houghton Mifflin
Harcourt Publishing Company. All rights reserved.

Page 88-89
BILL VIOLA, *Bodies of Light*, 2006
Black-and-white video diptych on plasma displays mounted on wall, 40
1/4 x 48 x 4 1/4 in, 21:27 minutes, Performers: Jeff Mills, Lisa Rhoden
Photo: Kira Perov
Quotation by RUMI

Page 90-91
PARMIGIANINO, *Self-Portrait in a Convex Mirror*, 1523–24
Oil on wood, Diameter 24.4 cm
Kunsthistorisches Museum, Vienna, Austria
Photo: Photobusiness – ARTOTHEK
"Self-Portrait in a Convex Mirror" by JOHN ASHBERY
from *Self-Portrait in a Convex Mirror*, copyright © 1974 by John
Ashbery. Used by permission of Viking Books, an imprint of Penguin
Publishing Group, a division of Penguin Random House. Reprinted in
the United Kingdom by permission of Carcanet Press Limited.

Page 92-93
MICHAEL GOLDBERG, *Sardines*, 1955
Oil and adhesive tape on canvas, 80 3/4 x 66 in.
Washington DC, Smithsonian American Art Museum, Gift of Mr. and
Mrs. David K. Anderson, Martha Jackson Memorial Collection
Photo: 2015. Photo Smithsonian American Art Museum/Art Resource/
Scala, Florence
"Why I Am Not a Painter" from *The Collected Poems of Frank O'Hara*
by FRANK O'HARA, copyright © 1971 by Maureen Granville-Smith,
Administratrix of the Estate of Frank O'Hara, copyright renewed 1999
by Maureen Granville-Smith and Donald Allen. Used by permission of
Alfred A. Knopf, an imprint of the Knopf Doubleday Publishing Group,
a division of Penguin Random House LLC. All rights reserved.

Page 94-95
Detail of the so-called *"Elgin Marbles": Demeter and Iris*, 447–440 BC
West pediment, Parthenon / Sculpture, Pentelic marble, London, British
Museum
Photo: akg-images / De Agostini Picture Lib. / A. C. Cooper
"On Seeing the Elgin Marbles" by JOHN KEATS

Page 96-97
FLEMISH PAINTER (previously attributed to Leonardo da Vinci),
Medusa's Head, c. 1600
Florenz, Galleria degli Uffizi
Photo: bpk | Scala — courtesy of the Ministero Beni e Att. Culturali
"On the Medusa of Leonardo da Vinci in the Florentine Gallery"
by PERCY BYSSHE SHELLEY

Page 98-99
CY TWOMBLY, *Untitled (Say Goodbye, Catullus, to the Shores of Asia
Minor)*, 1994
Oil, acrylic, oil stick, crayon, and graphite pencil on three canvases,
overall: 157 1/2 x 624 in.
The Menil Collection, Houston, Gift of the artist
Photo: Hickey-Robertson, Houston
"The Ninth Elegy (The Duino Elegies)" by RAINER MARIA RILKE

Page 100-101
AUGUSTUS SAINT-GAUDENS, Detail of the *Memorial to Robert
Gould Shaw and the 54th Massachusetts Volunteer Infantry*,
Cornish, New Hampshire, USA
Photo: Lee Snider/Photo Images/Corbis
Excerpt from "For the Union Dead" by ROBERT LOWELL from
Collected Poems. Copyright © 2003 by Harriet Lowell and Sheridan
Lowell. Reprinted by permission of Farrar, Straus & Giroux.

Page 102-103
JOHANNES VERMEER, *The Milkmaid*, c. 1658–60
Oil on canvas, 45.5 x 41 cm
Rijksmuseum, Amsterdam, The Netherlands
Photo: Bridgeman Images
"Vermeer" by WISŁAWA SZYMBORSKA
from *Poems New and Collected*, copyright © 2000 by Houghton Mifflin
Harcourt Publishing Company. Reprinted by permission of Houghton
Mifflin Harcourt Publishing Company. All rights reserved.

Page 104-105
SIR JOHN EVERETT MILLAIS, *Ophelia*, 1851–52
Oil on canvas, 70 x 110 cm
Photo: Tate, London
"Hamlet" by WILLIAM SHAKESPEARE

Page 106-107
PIETER BRUEGHEL THE ELDER, *Hunters in the Snow*, 1565
117 x 162 cm
Kunsthistorisches Museum, Vienna, Austria
Photo: Bridgeman Images
"Winter Landscape" by JOHN BERRYMAN from *Collected Poems:
1937-1971*. Copyright © 1989 by Kate Donahue Berryman. Reprinted
by permission of Farrar, Straus & Giroux. Reprinted in the United
Kingdom by permission of Faber & Faber, Ltd.

Page 108-09
MARC CHAGALL, *The Bride*, 1938–39
148 x 145 cm
Private Collection
Photo: Blauel/Gnamm – ARTOTHEK
"To Marc Chagall" by PAUL ÉLUARD
from *Le Dur Désir du Durer*, copyright © 1950 by Trianon Press.
Translated by Stephen Spender and Frances Cornford. Reprinted with
permission sought by Trianon Press.

Front, Back Cover, Frontispiece, and Page 140:
Detail from Georges Seurat, *A Sunday on La Grande Jatte,*
1884

Page 1, Back Cover:
Excerpt from *Seurat's Sunday Afternoon Along the Seine*
by Delmore Schwartz

Prestel Verlag, Munich
A member of Verlagsgruppe Random House GmbH
Neumarkter Strasse 28
81673 Munich
Tel. +49 (0)89 4136-0
Fax +49 (0)89 4136-2335
www.prestel.de

Prestel Publishing Ltd.
14-17 Wells Street
London W1T 3PD
Tel. +44 (0)20 7323-5004
Fax +44 (0)20 7323-0271

Prestel Publishing
900 Broadway, Suite 603
New York, NY 10003
Tel. +1 (212) 995-2720
Fax +1 (212) 995-2733
www.prestel.com

Library of Congress Control Number: 2015942929

British Library Cataloguing-in-Publication Data: a
catalogue record for this book is available from the British
Library; Deutsche Nationalbibliothek holds a record of
this publication in the Deutsche Nationalbibliografie;
detailed bibliographical data can be found under:
http://www.dnb.de

Design and layout: Judith Hudson
Text permissions: Rebecca Pennucci, Janis Staggs
Research: Olivia Schaaf
Image editing: Juliane Eisele
Production: Andrea Cobré
Origination: Reproline Mediateam, Munich
Printing and binding: DZS Grafik, Ljubljana
Typeface: Scala, Nobel, and Adobe Garamond
Paper: Condat Perigord, 170 g

ISBN 978-3-7913-5477-4

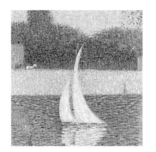